# TINY

# TOKYO

# TINY
# TOKYO

## The Big City Made Mini

by BEN THOMAS

CHRONICLE BOOKS
SAN FRANCISCO

Library of Congress Cataloging-in-Publication Data
available.

ISBN: 978-1-4521-1738-6

Manufactured in China

MIX
Paper
FSC  FSC® C104723

Designed by Emily Dubin
Map by Lohnes + Wright

10 9 8 7 6 5 4 3 2 1

Chronicle Books LLC
680 Second Street
San Francisco, CA 94107
www.chroniclebooks.com

FOR KATHERINE

& ASHER

I've been making tilt-shift photographs for the past half-dozen years. Tilt-shift photography is a technique that transforms ordinary images into images that take on the appearance of a miniature or a diorama. The original intended use of a tilt-shift lens mostly rested with architectural photographers using the additional movement of the lens (tilting and shifting) to help correct perspective distortion when shooting an architectural subject.

The technique is used in a number of ways to produce vastly different results. Over the years, a number of photographers have experimented with a tilt-shift lens to produce a variety of effects—most notably, the lens, in reducing the depth of field of a scene, will lend the impression of a toy or miniature setting. Reducing depth of field decreases the field of focus, which can produce the optical illusion that items are much smaller than they really are. In addition to this, considerations such as perspective, distance, framing, and color greatly contribute to the success of an image.

For me, the tilt-shift effect provided the opportunity to experiment with ideas of make-believe in the context of the real world and how we relate the two. With this effect, a scene tends to look shiny and new, as if it's been given a fresh start. I hope for my images to be instantly familiar, but also just strange enough to encourage that second, deeper look. In presenting real scenes as dioramas, I have found that the viewer will look at a scene that is perhaps very familiar with fresh eyes and often with nostalgia and a sense of exploration and fun.

I first visited Tokyo in 2008, and it was one of the most influential experiences of my life. Its character is spectacularly suited to this style of photography. I didn't anticipate then that I would return to the city on an almost annual basis, but in hindsight I'm not surprised. Each visit is filled with photographic opportunity and an almost unlimited array of subject matter to explore.

Tokyo, on the face of it, is anything but miniature. It is gigantic—a seemingly endless metropolis. It is brash and bold and larger than life.

However, look a little deeper, and you will see that Tokyo is not that obvious. There is a lot going on under the surface. The people of Tokyo are deeply mindful of others and of harmony in all areas. They have one of the most customer-centric societies I have come across and display meticulous attention to detail in all things from signage to train timetables. You can't help but think that this level of sophistication and concern must be nonnegotiable in a city as large and as crowded as Tokyo, and if it isn't, perhaps it should be.

Japan is also a country of contradictions, and Tokyo is the hub where these contradictions are most clear— ancient versus modern, tradition versus innovation. Tokyo is fast paced yet welcoming, wild yet restrained, difficult yet safe, adventurous yet home-loving. Around every corner is another surprise, and almost all of them are good. As much as any of this though, Tokyo is a visual feast. So much of what makes Tokyo such a thoroughly engaging experience is in what you see around you. For me especially, so many of the elements

that I find interesting relate to the details: the guy working on his boat, the blue building dwarfed by the gray ones, the guy on first base trying to steal second. Through this approach, the detail that would ordinarily be in the background can be brought into focus. This is what I love about tilt-shift photography. I hope you do, too.

For the most part, the places in this book are those that anyone can easily visit on a trip to Tokyo. But I hope I've shown them here in a new and different light. The images offer a snapshot of a city that is running to its own beat, a culture that is warm and exciting and a wonderful mix of the old and new.

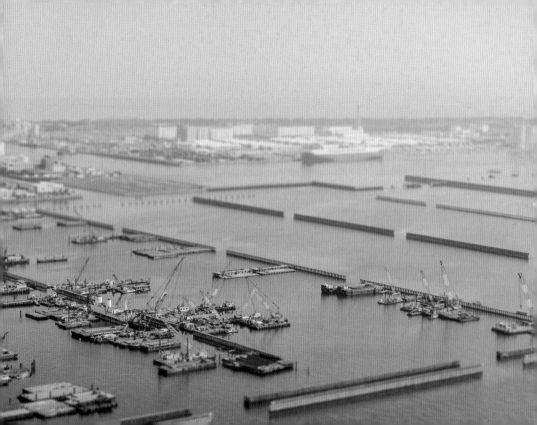

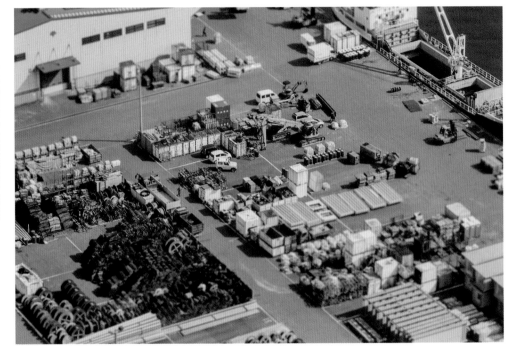

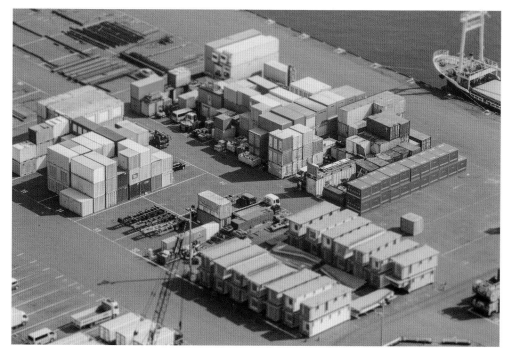

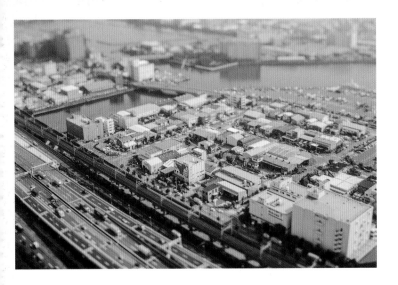

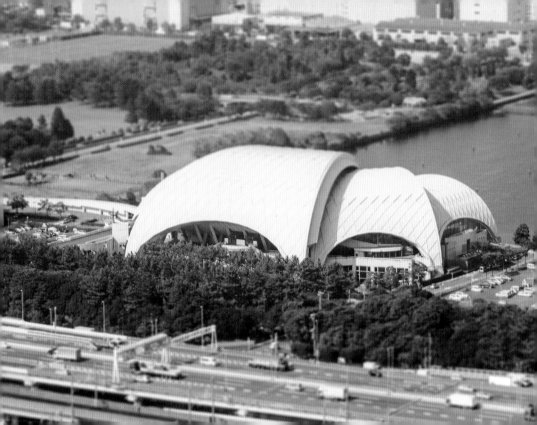

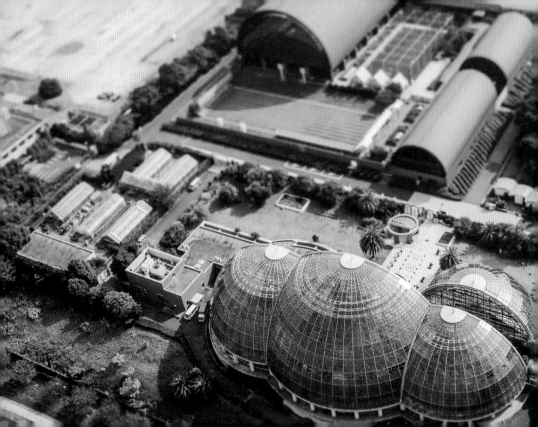

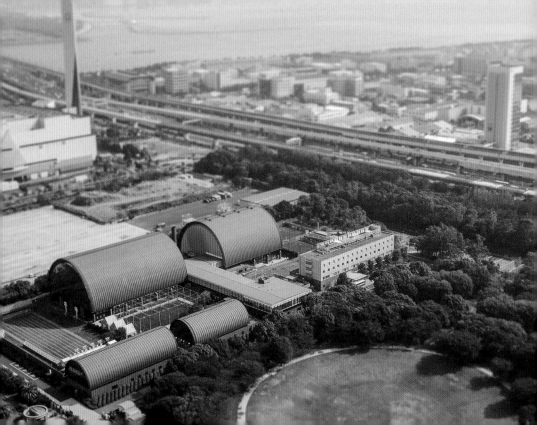

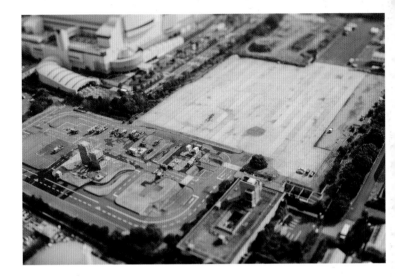

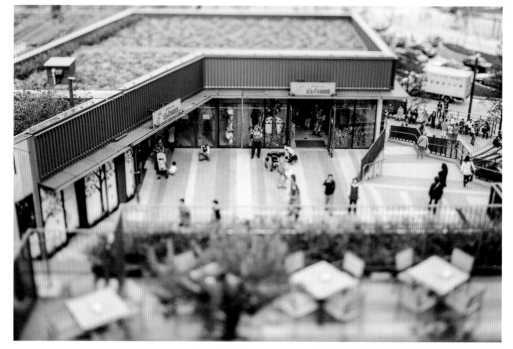

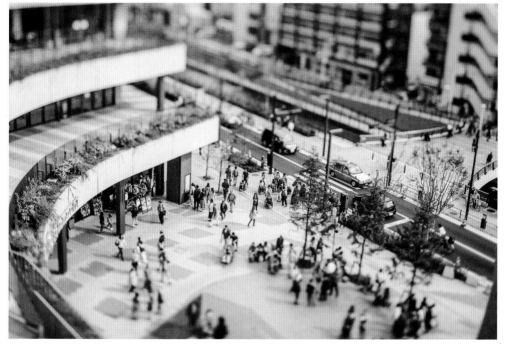

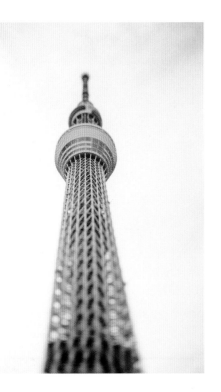

→ OSHIAGE WALKWAY, SUMIDA

← TOKYO SKYTREE, SUMIDA

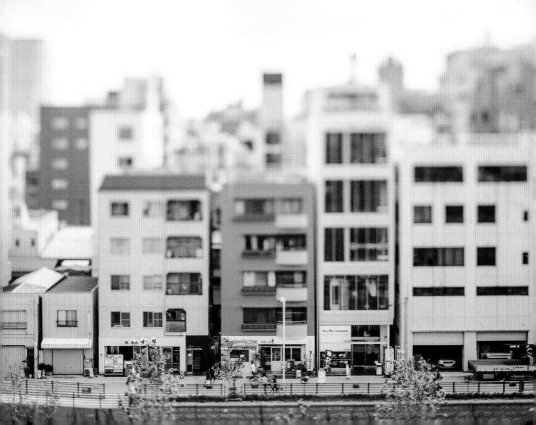

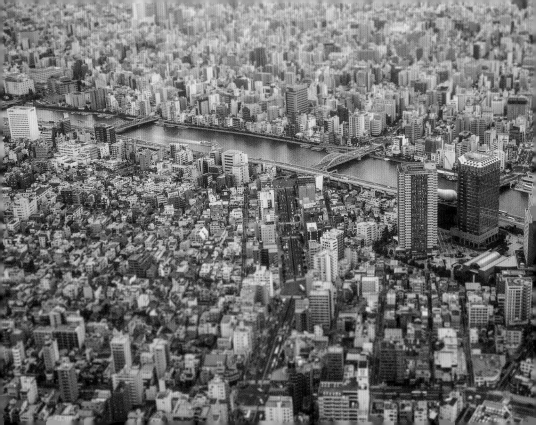

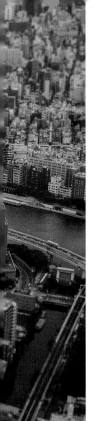

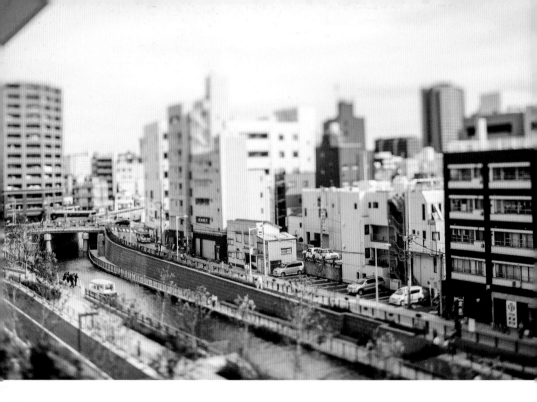

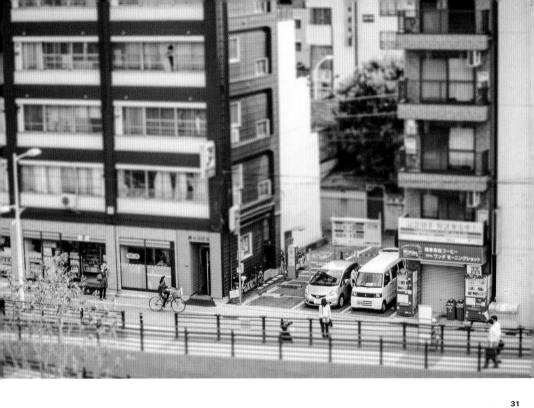

INTERSECTION AT NIGHT, OSHIAGE

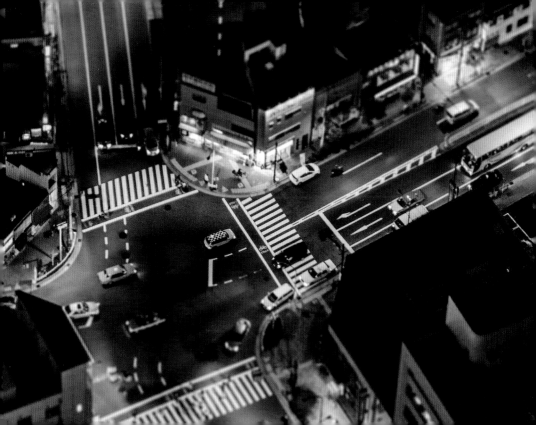

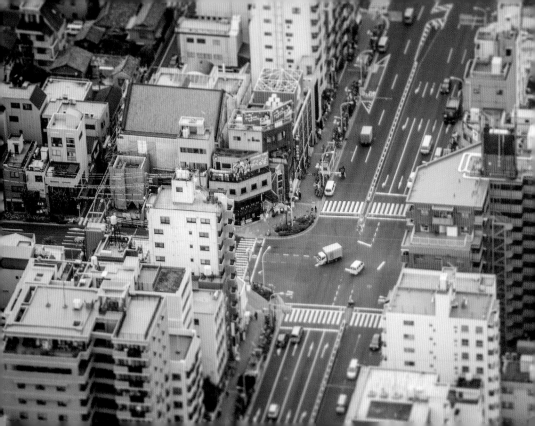

→ ENTRANCE TO SENSO-JI TEMPLE, ASAKUSA

← INTERSECTION ABOVE HONJO AZUMABASHI SUBWAY, SUMIDA

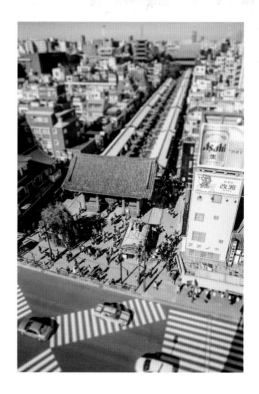

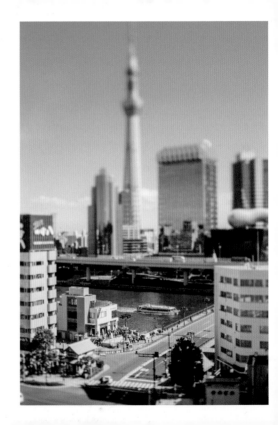

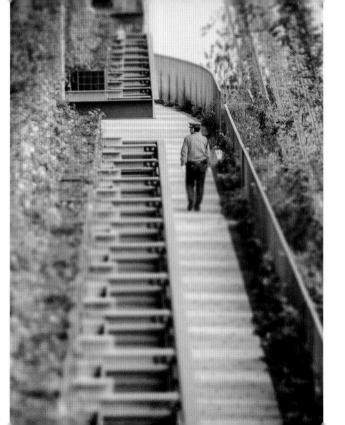

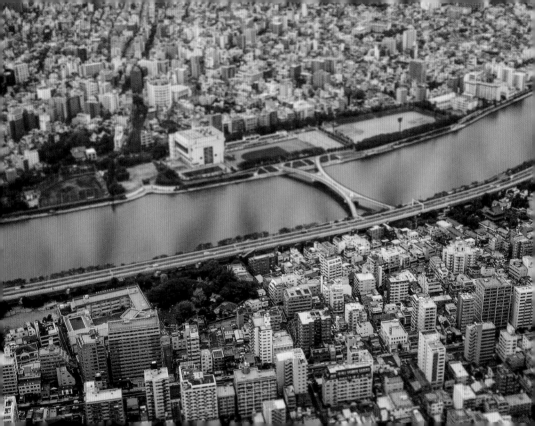

SAKURA BRIDGE, IMADO

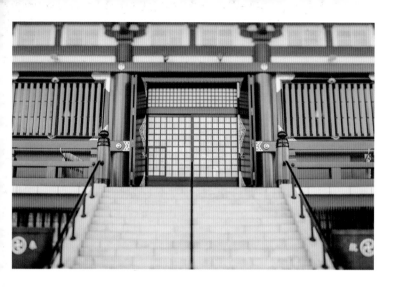

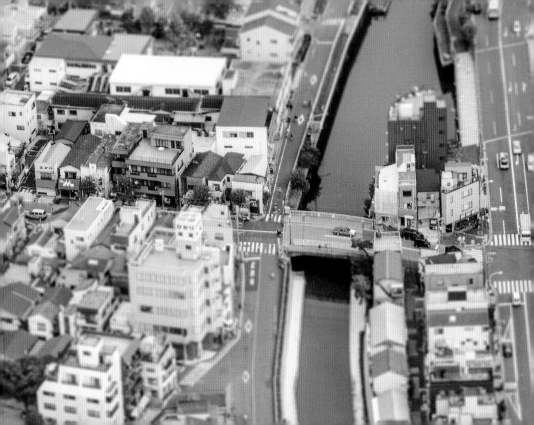

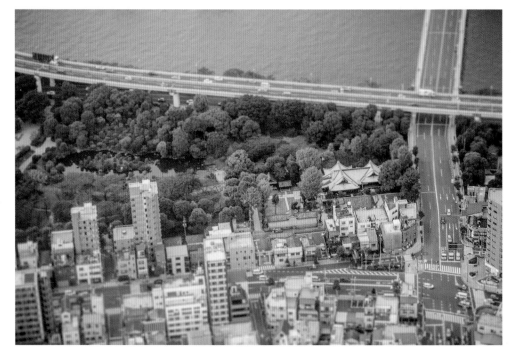

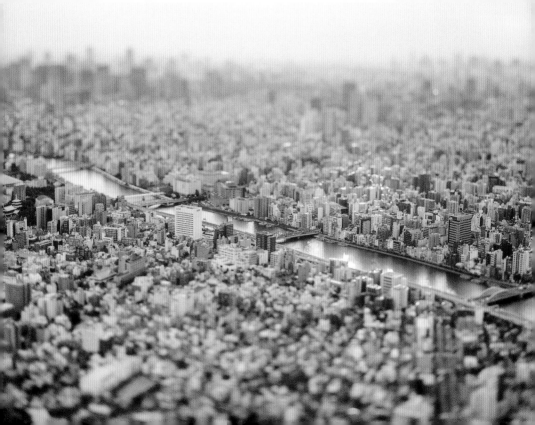

→ YOKOKAWA ELEMENTARY SCHOOL, SUMIDA

→ GARDENS IN TAIHEI, SUMIDA

← SUMIDA CITYSCAPE, TOKYO

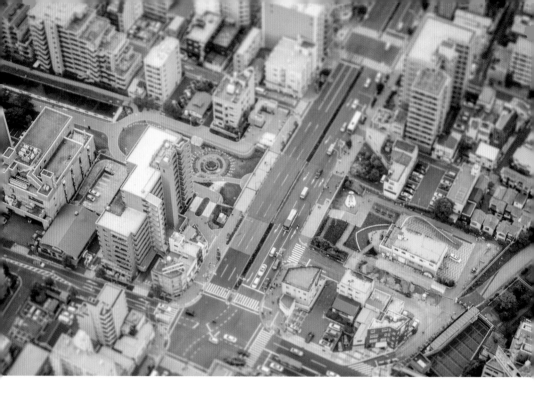

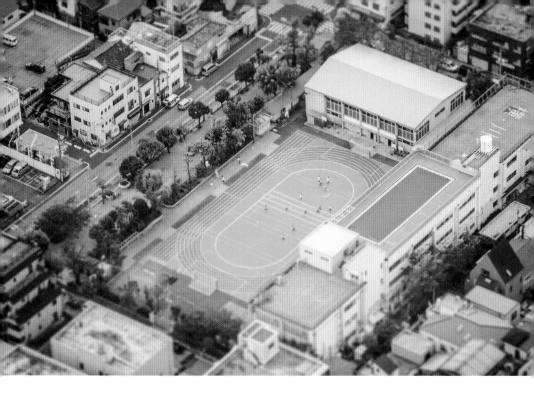

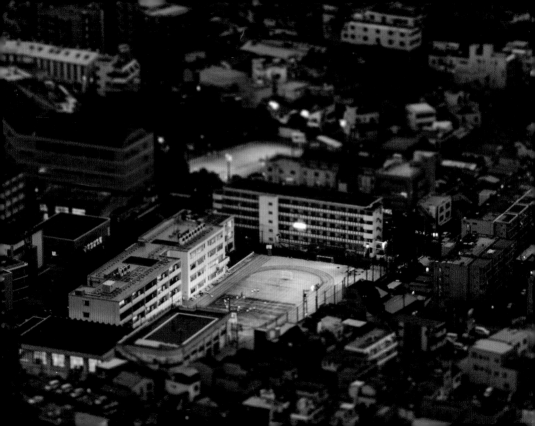

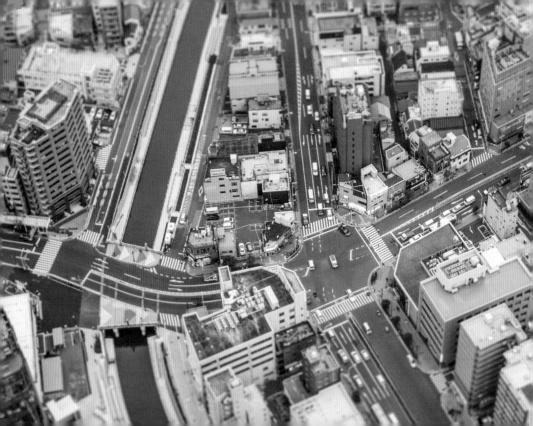

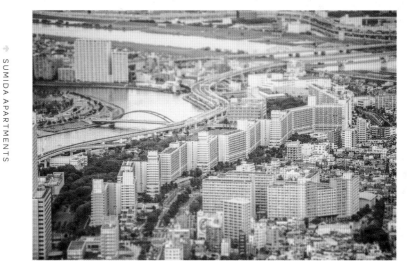

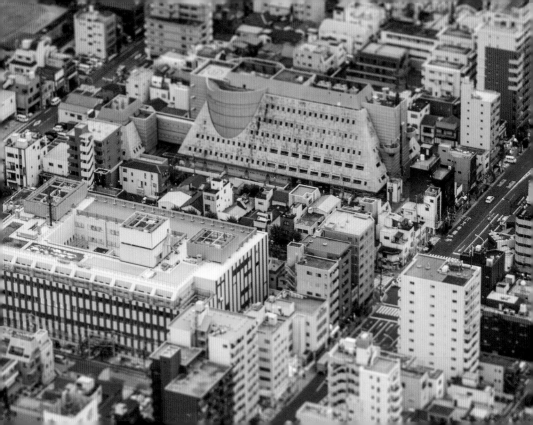

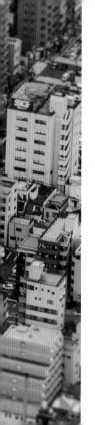

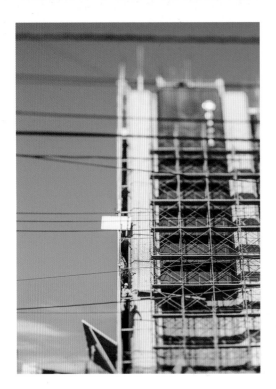

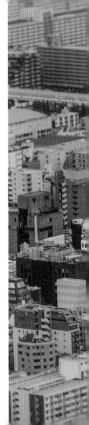

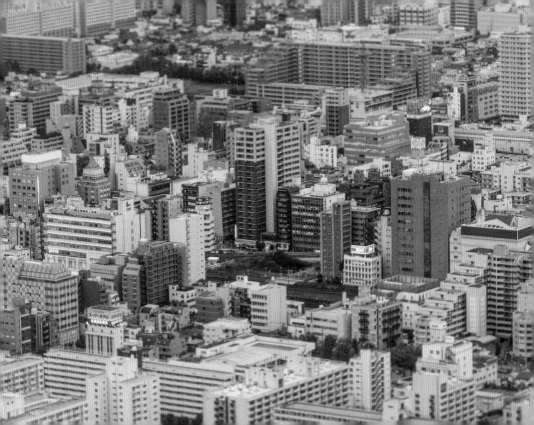

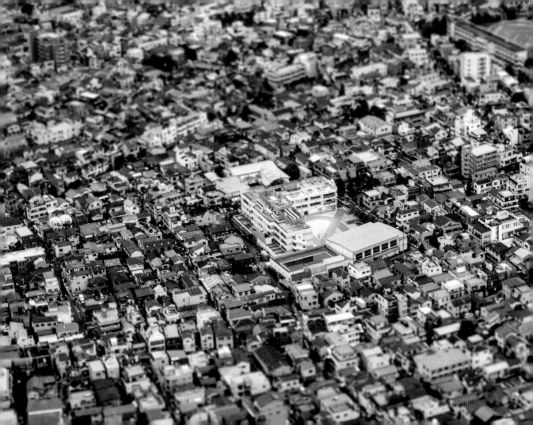

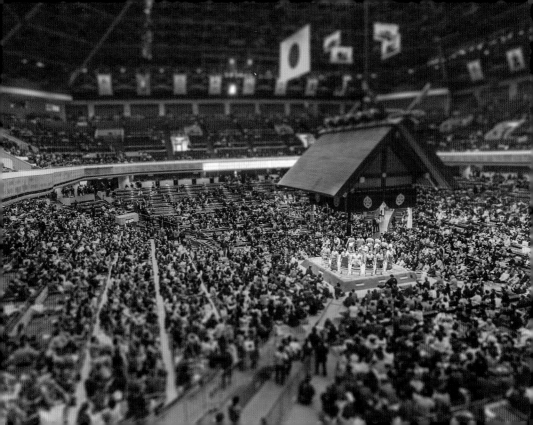

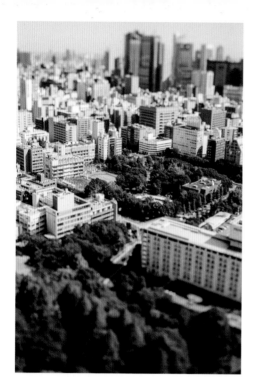

SAKURADA DORI, MINATO

ONARIMON ELEMENTARY SCHOOL, SHIBAKOEN, FROM TOKYO TOWER

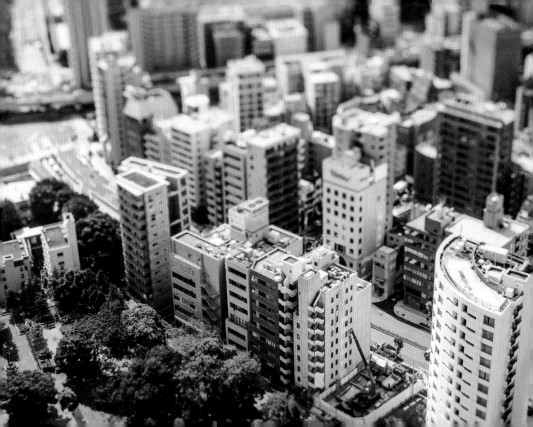

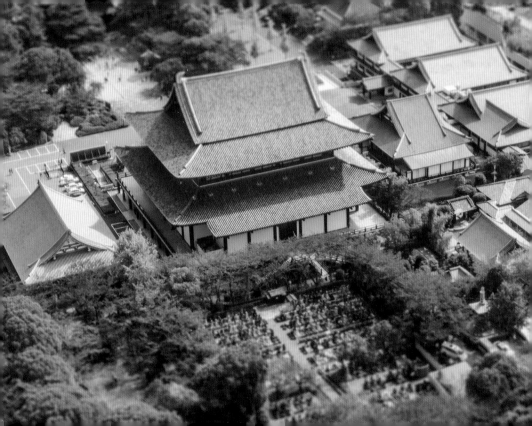

SHAKADEN REIYUKAI TEMPLE, MINATO

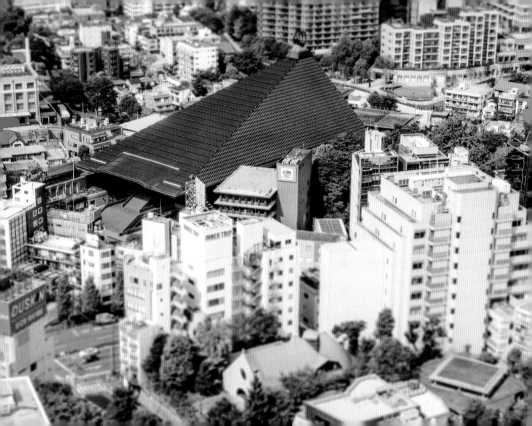

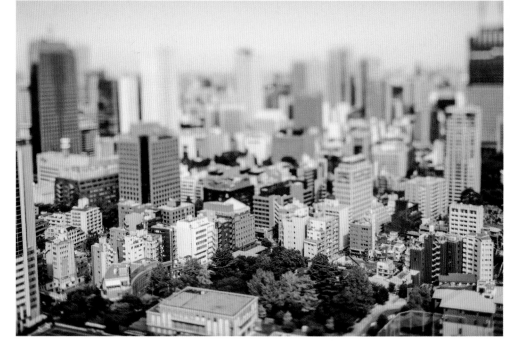

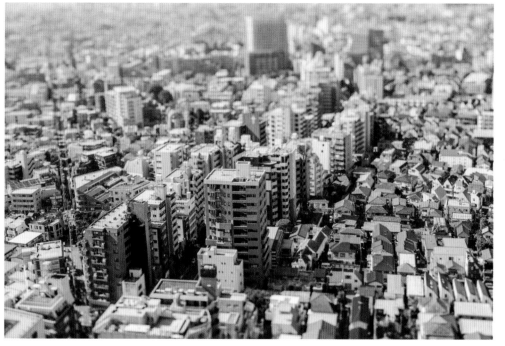

SANGENJAYA HI-LO RISE, SETAGAYA

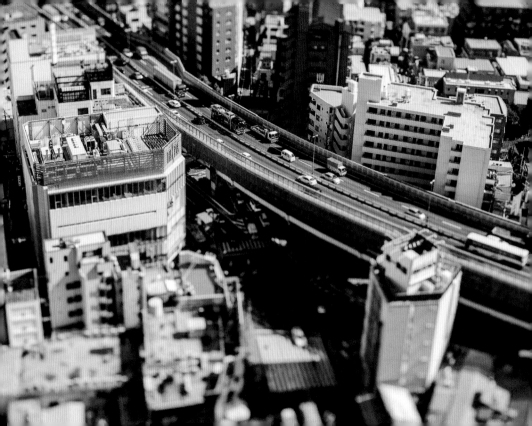

THE ROAD TO SANGENJAYA CARROT TOWER
→

METROPOLITAN EXPRESSWAY NO. 3
←

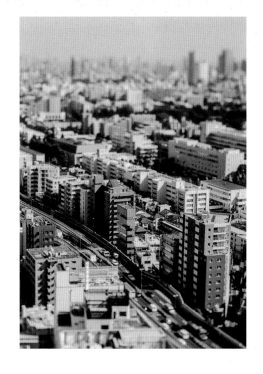

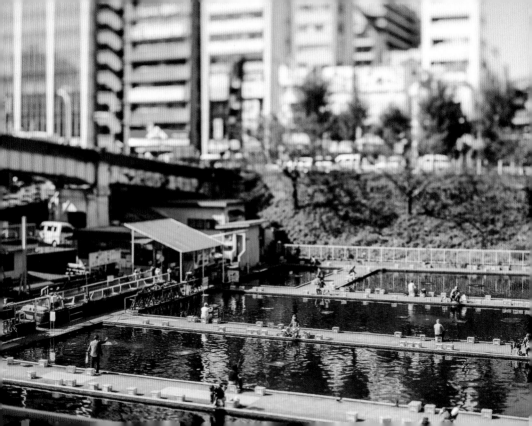

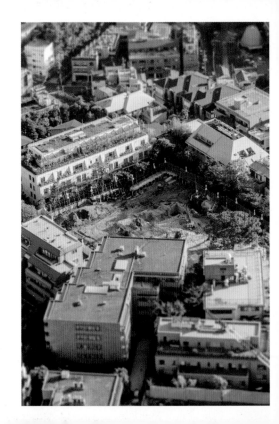

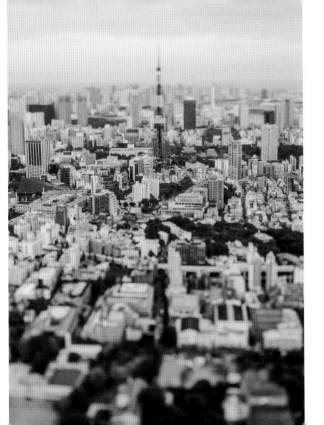

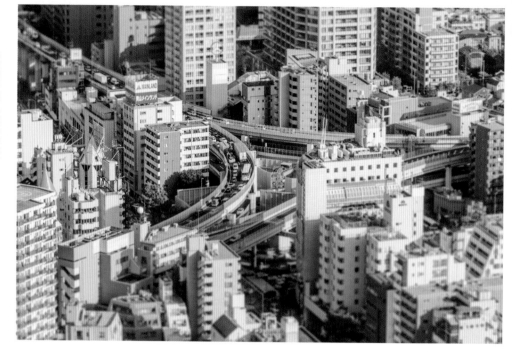

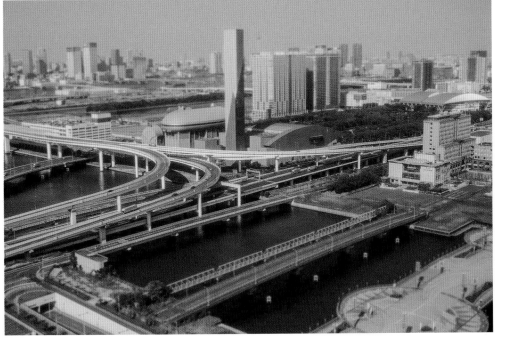

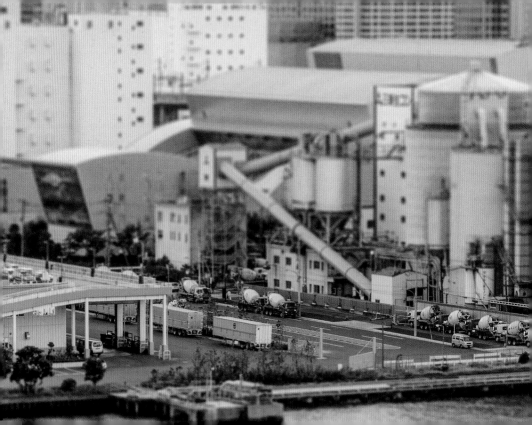

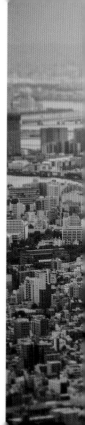

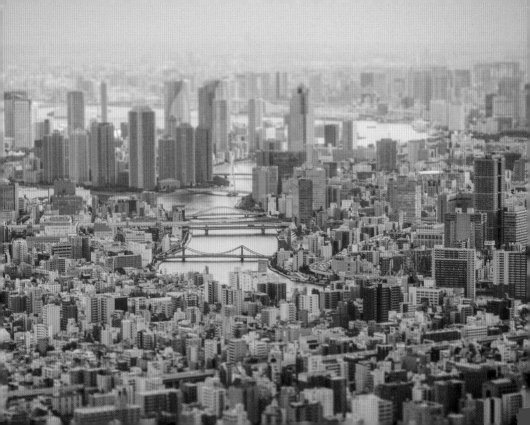

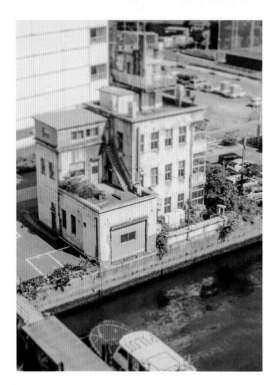

→ SHIBAURA DOCK, MINATO

← SHIBAURA PIER, MINATO

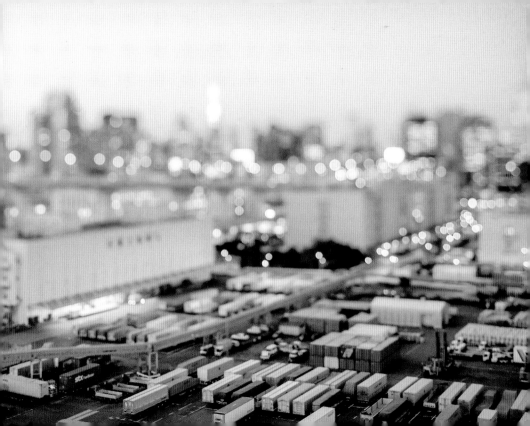

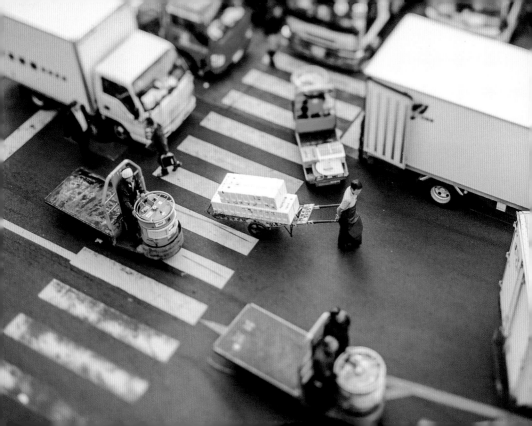

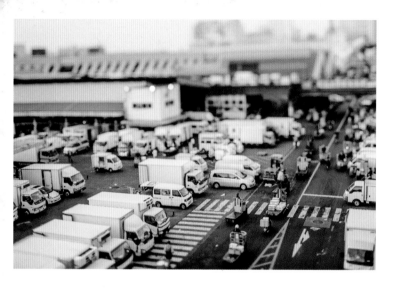

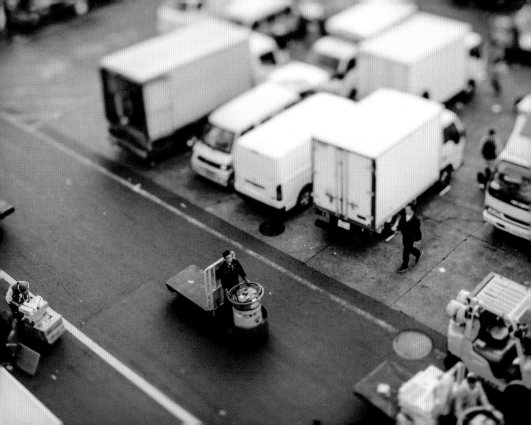

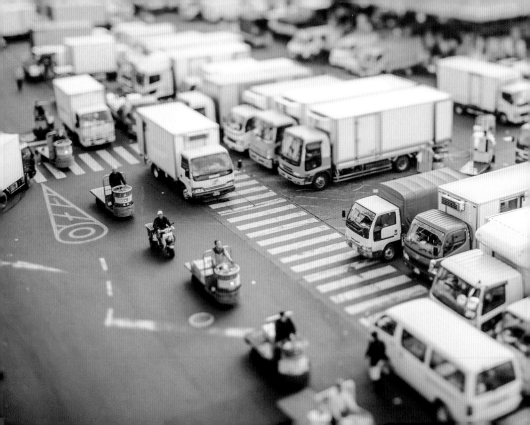

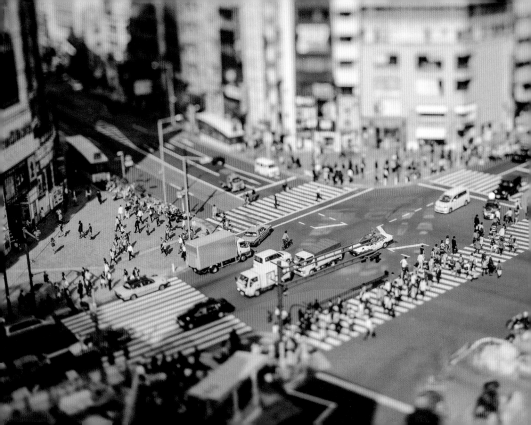

→ SHINJUKU CENTRAL PARK

→ SHINJUKU METRO

← SHIBUYA INTERSECTION

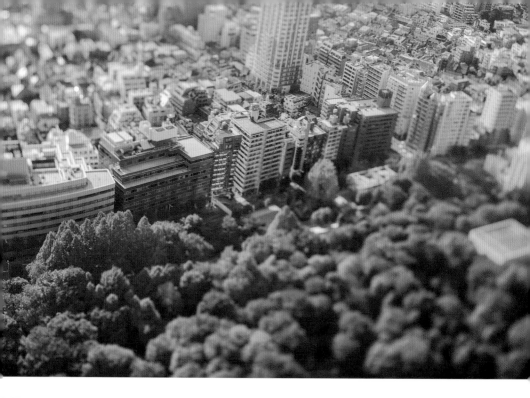

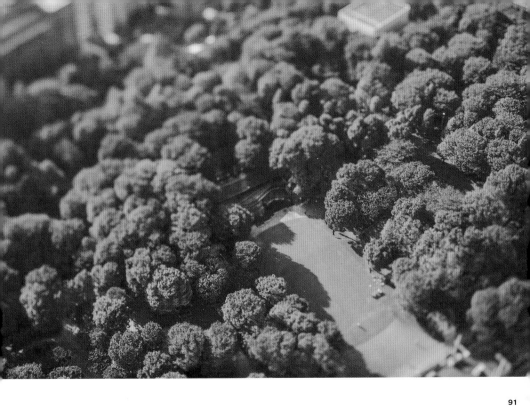

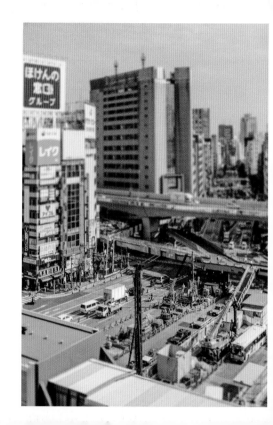

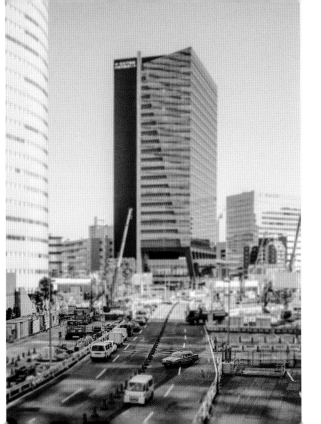

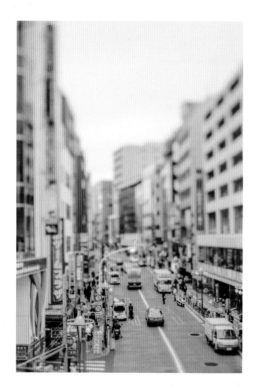

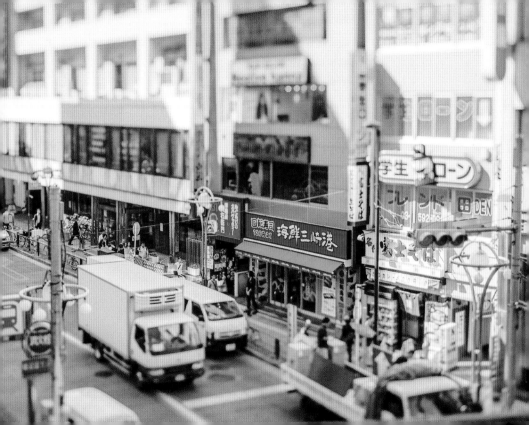

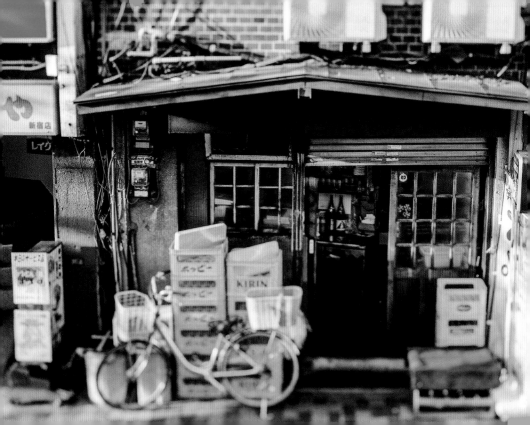

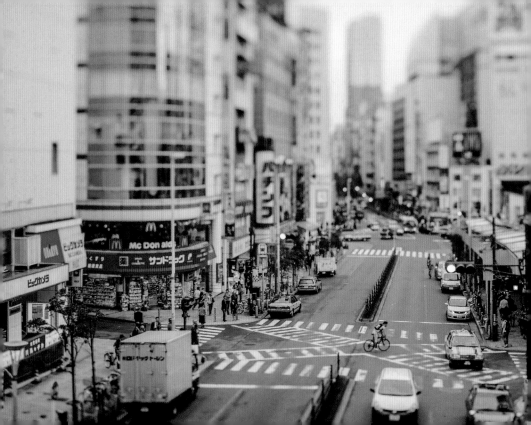

ROOFTOP WORKS, SHINJUKU

JUST BEFORE RUSH HOUR, SHINJUKU

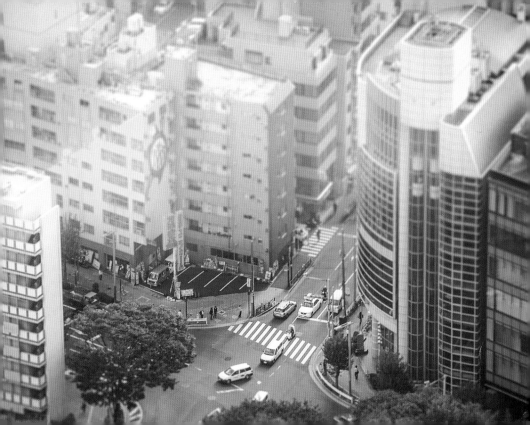

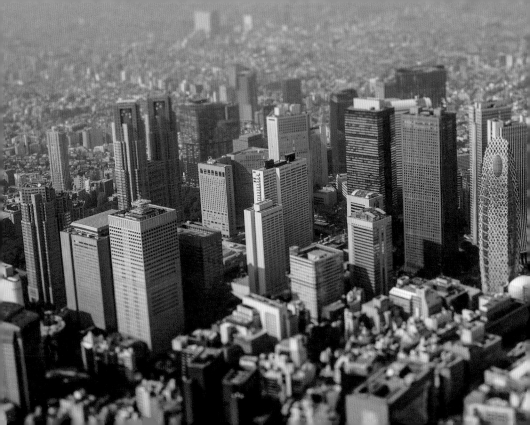

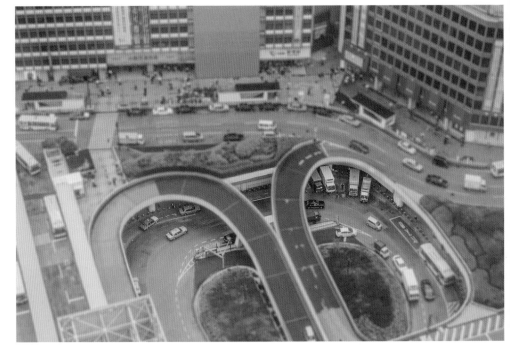

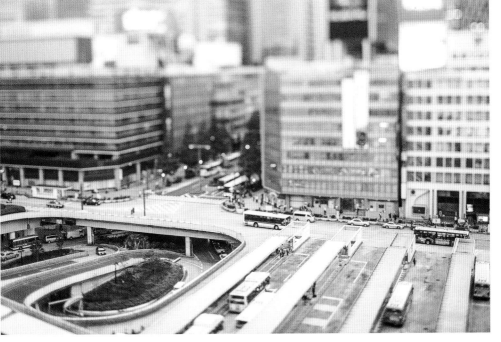

YOYOGI NATIONAL GYMNASIUM AND SHIBUYA-AX, YOYOGI PARK

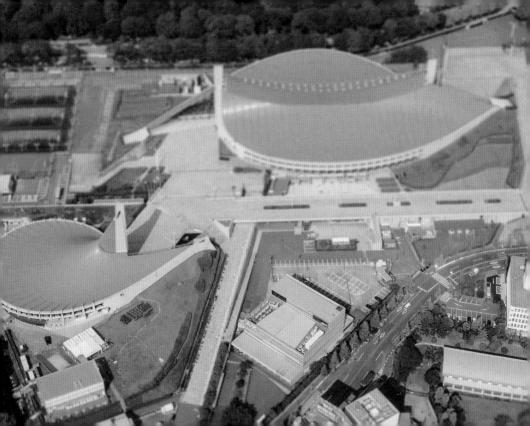

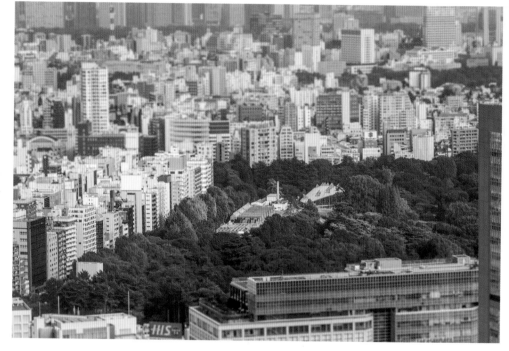

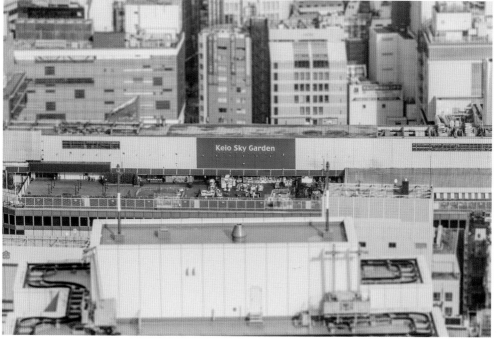

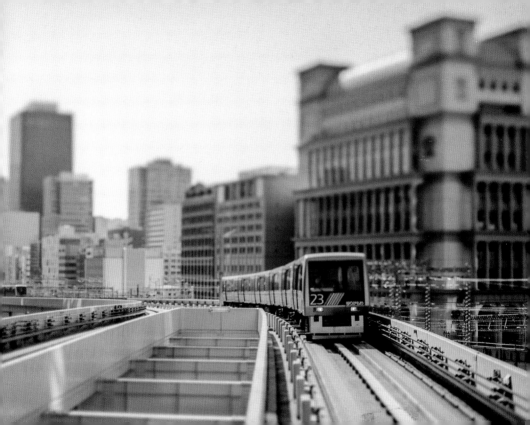

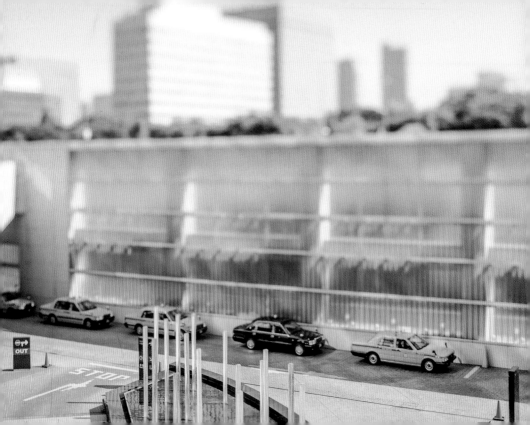

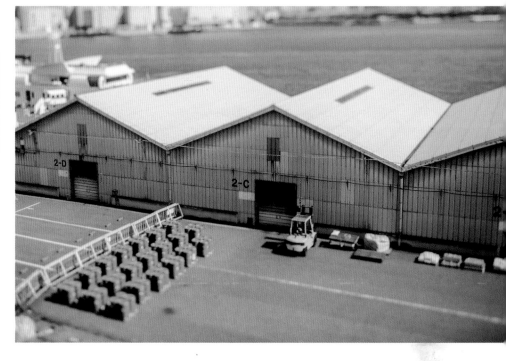

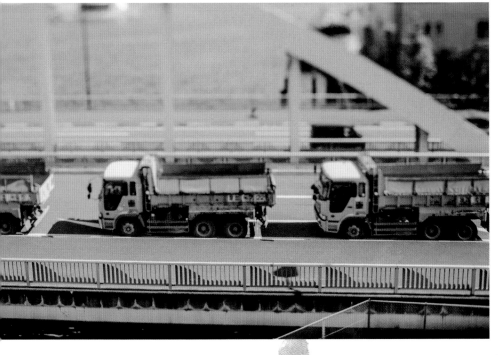

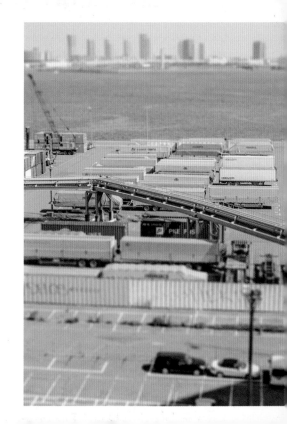

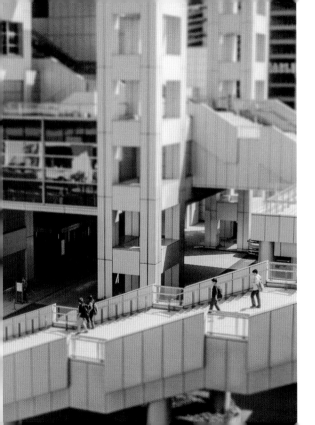

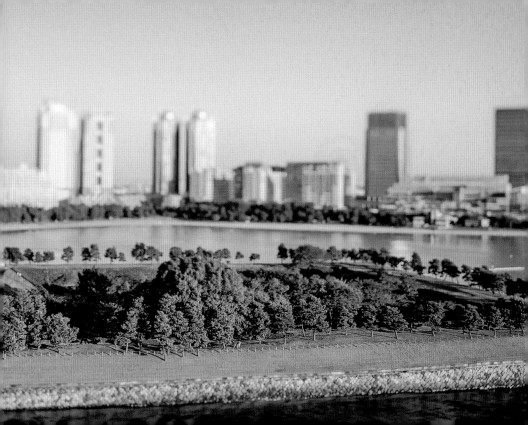

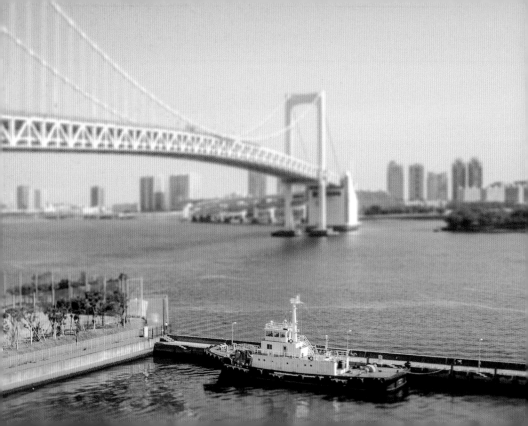

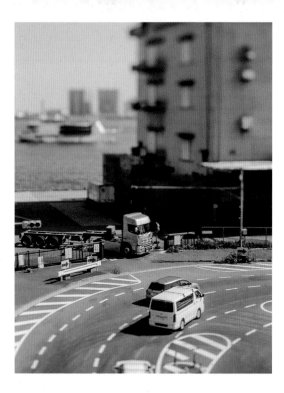

WAITING TO MOVE, HINODE

SEMITRAILER, HINODE

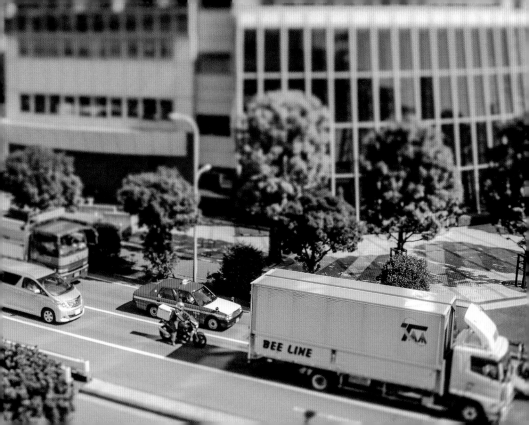

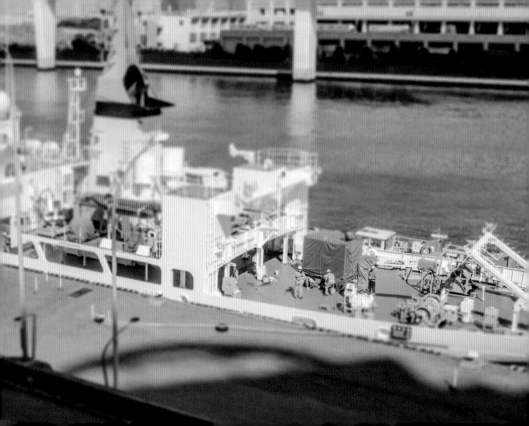

→ RALLY CARS, ODAIBA

→ G-ROBOT 2, DIVERCITY TOKYO, ODAIBA

SHIPSHAPE, SHIBAURA PIER, MINATO

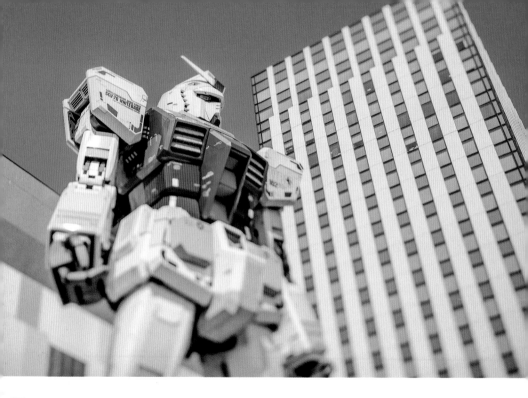

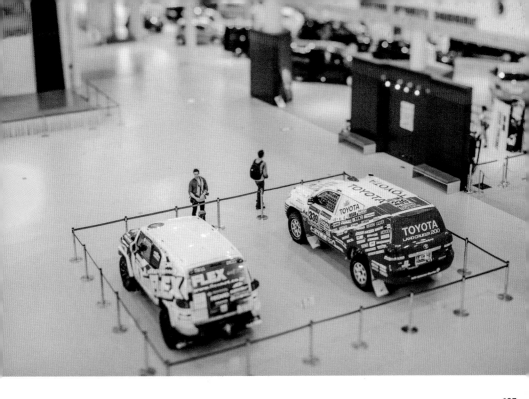

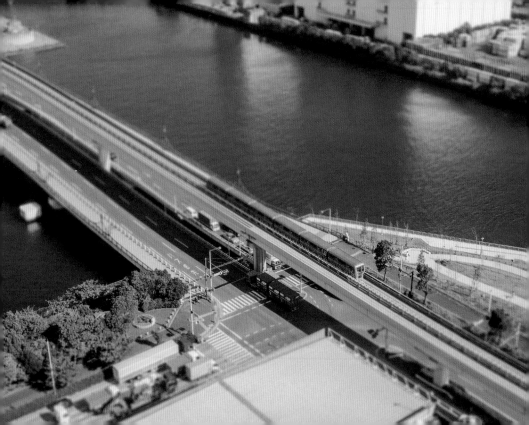

MONORAIL OVERPASS, ODAIBA

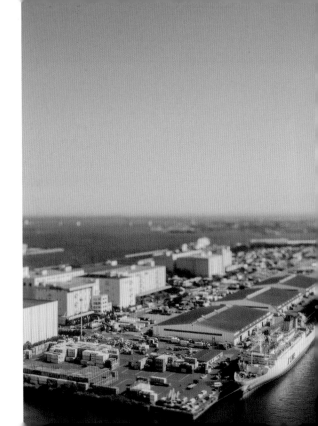

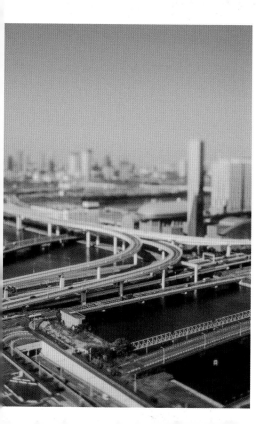

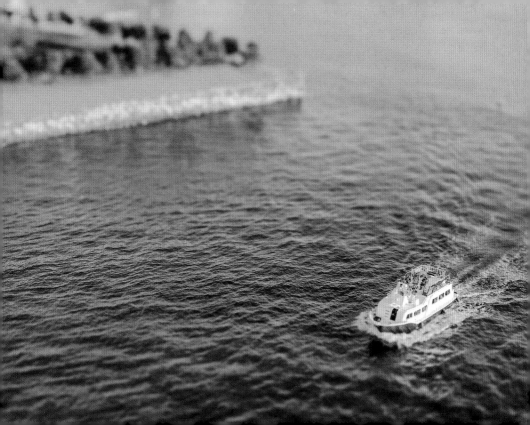

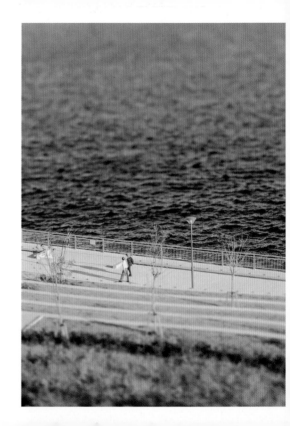

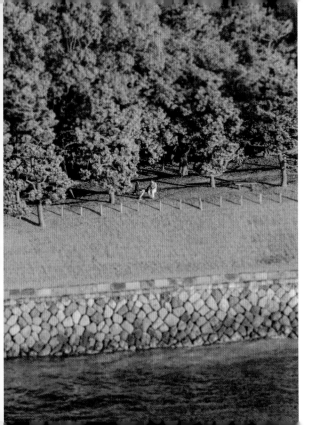

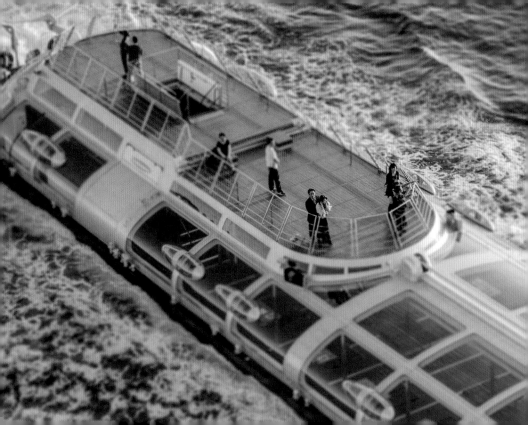

→ ON WATER, TOKYO BAY

← TOP DECK, TOKYO BAY

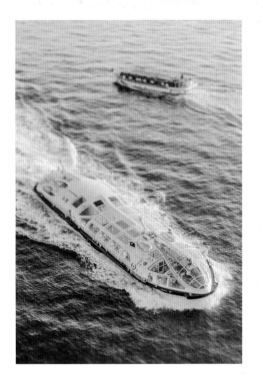

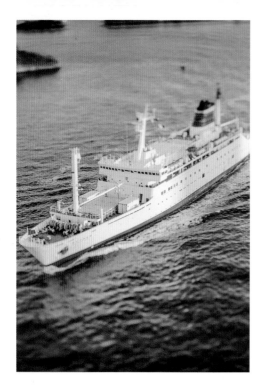

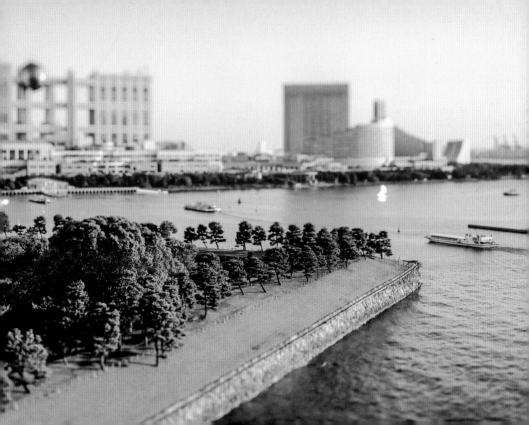

FISHERMEN HOMEWARD, TOKYO BAY

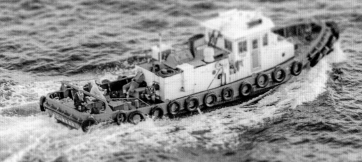

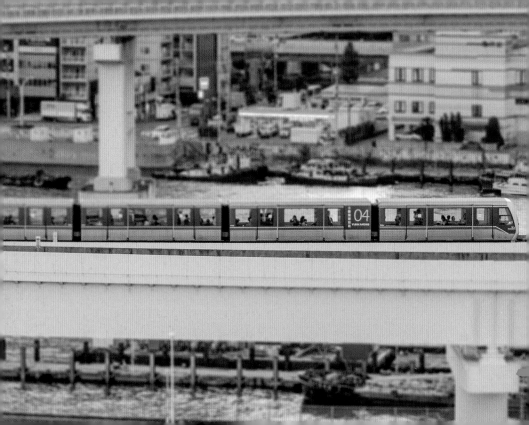

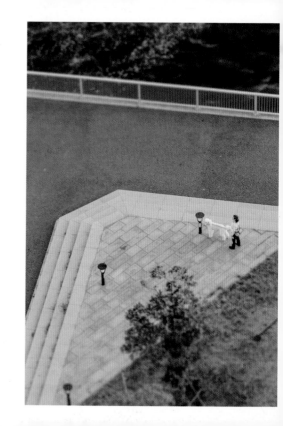

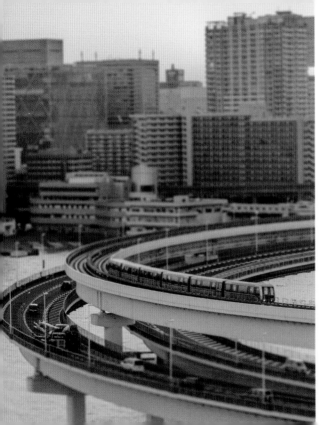

SUNSET DOCK, RAINBOW BRIDGE, MINATO

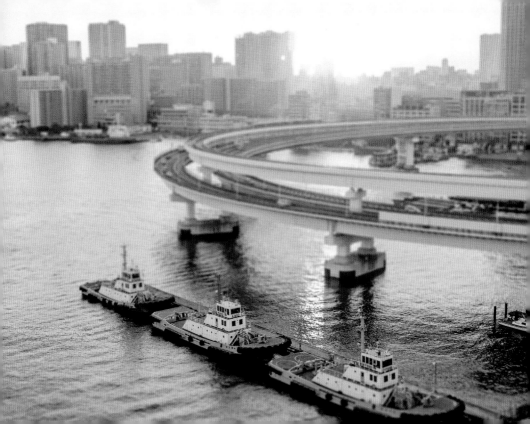

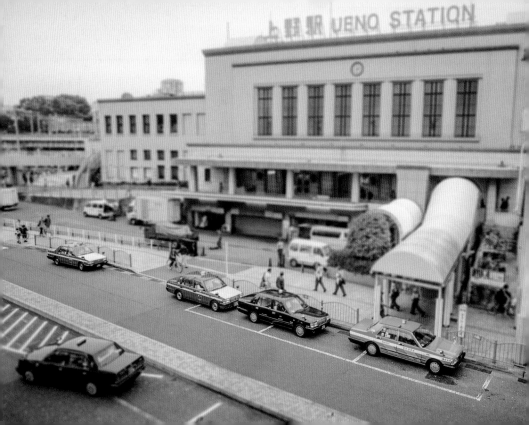

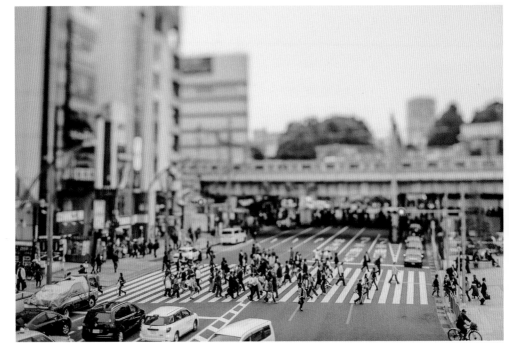

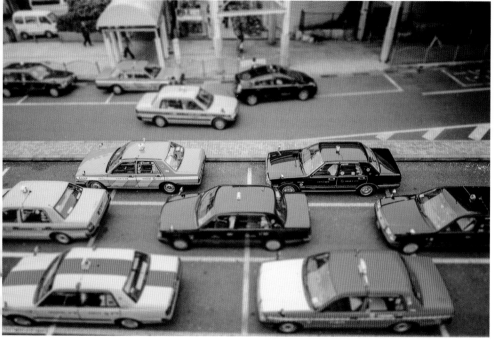

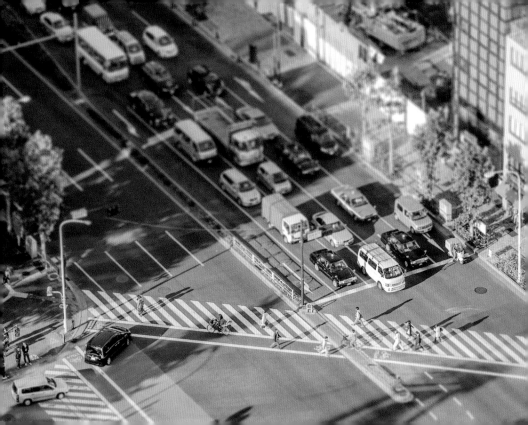

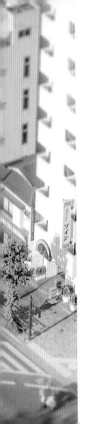

TOKYO DOME CROSSING, BUNKYO

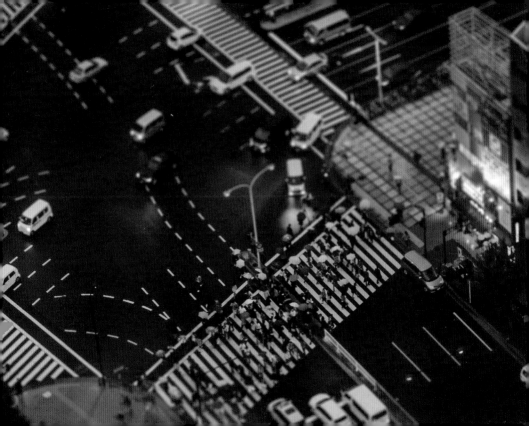

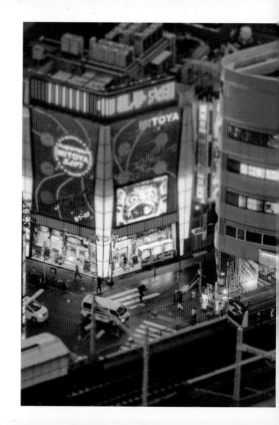

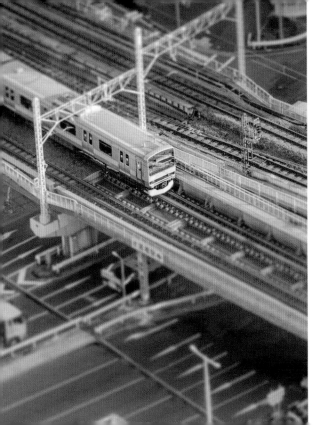

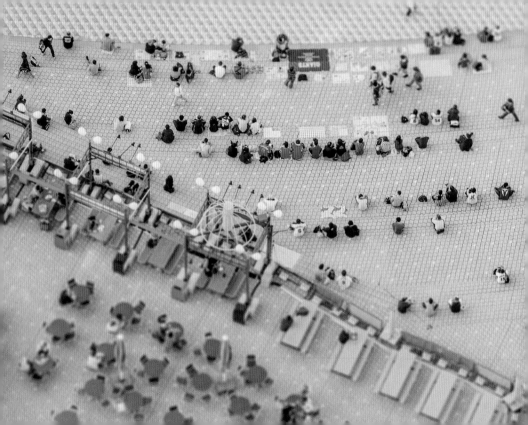

→ TOKYO DOME CROWD, BUNKYO

→ TOKYO DOME BASEBALL, BUNKYO

← WAITING FOR A GAME, TOKYO DOME, BUNKYO

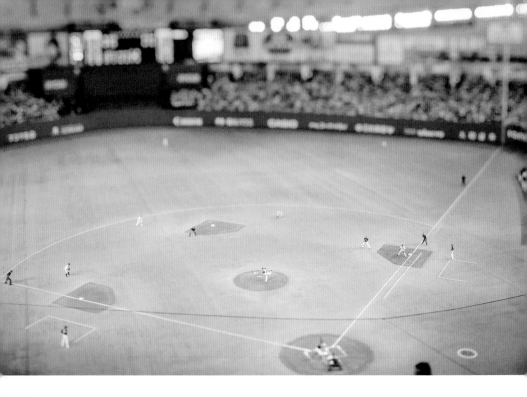

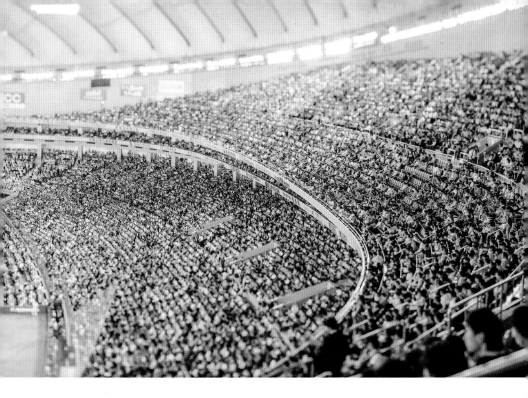

AMUSEMENT PARK, TOKYO DOME, BUNKYO

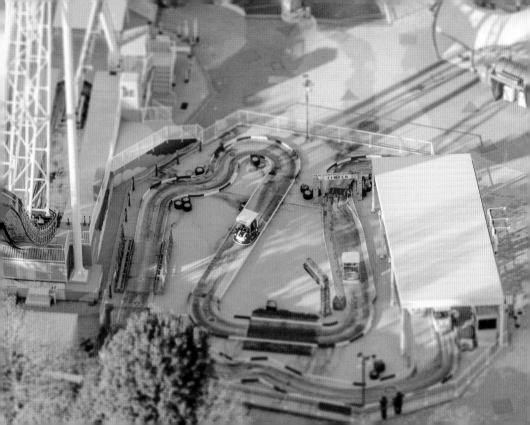

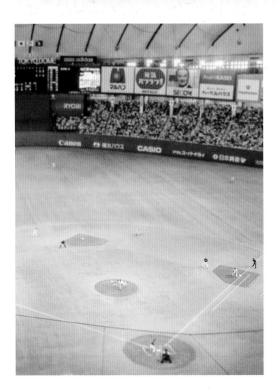

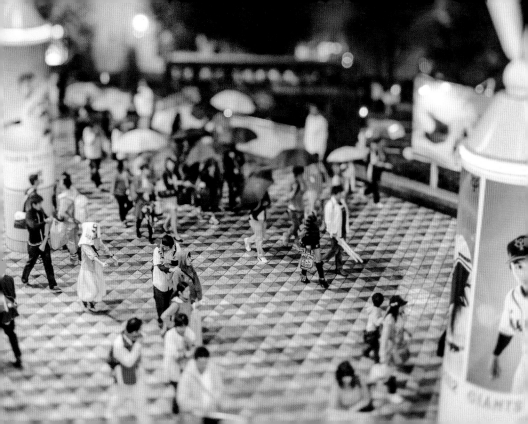

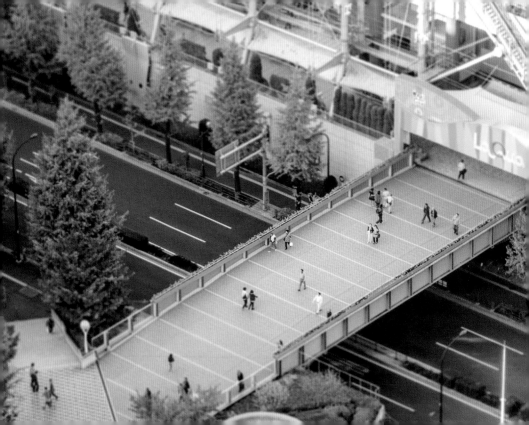

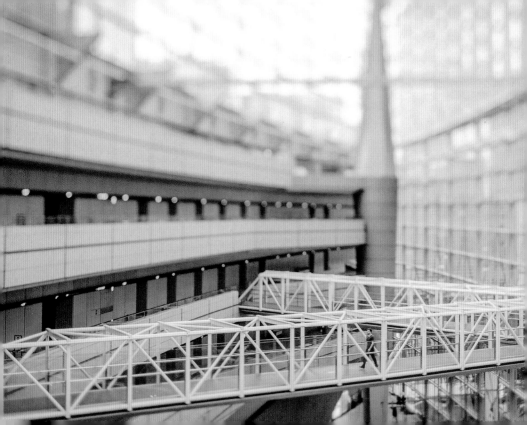

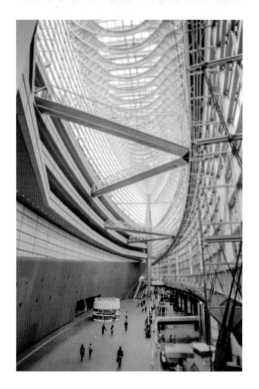

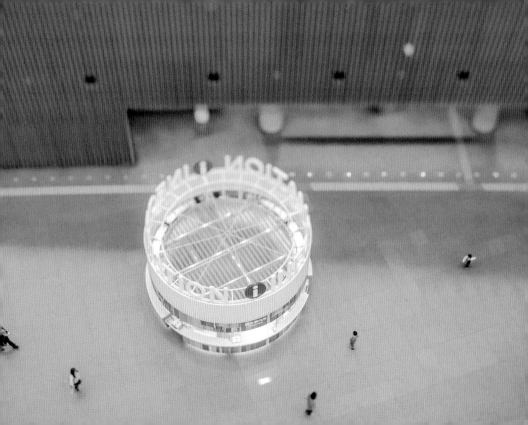

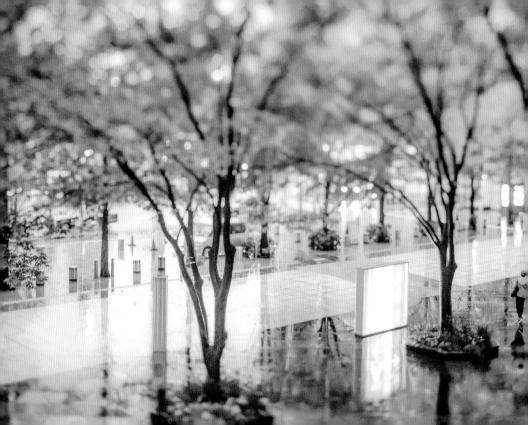

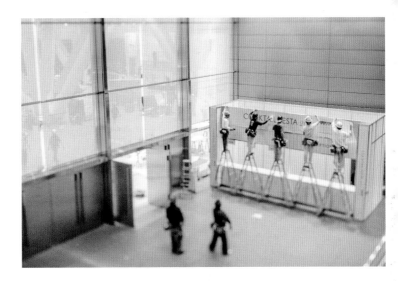

↑ → COCKTAIL PARTY PREPARATION, TOKYO INTERNATIONAL FORUM, CHIYODA

← WET FOOTPATH, CHIYODA

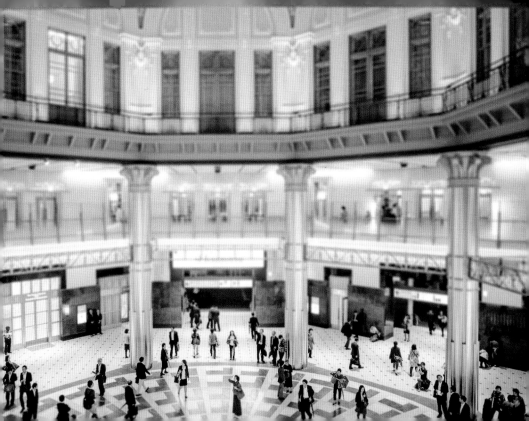

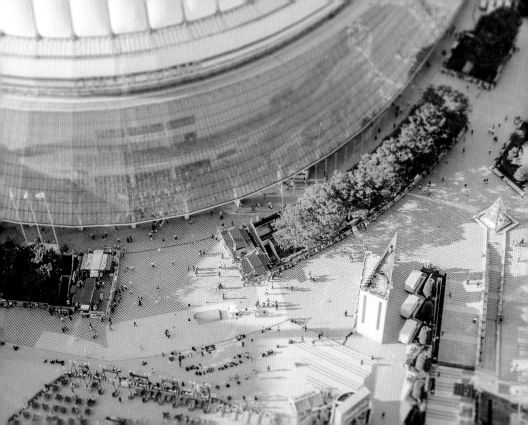

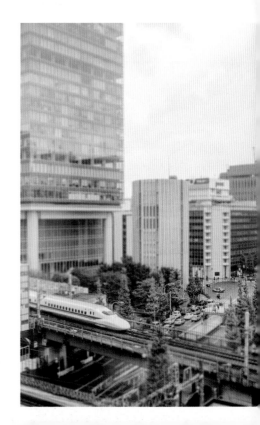

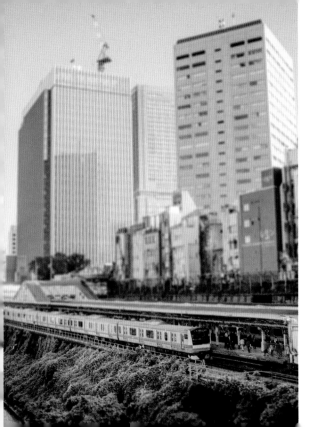

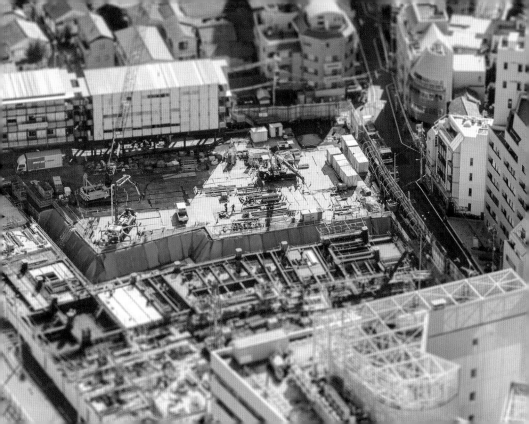

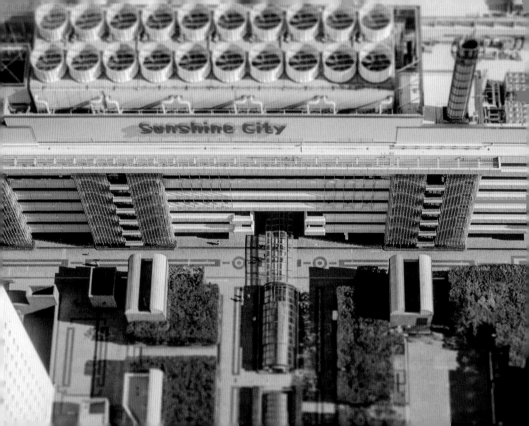

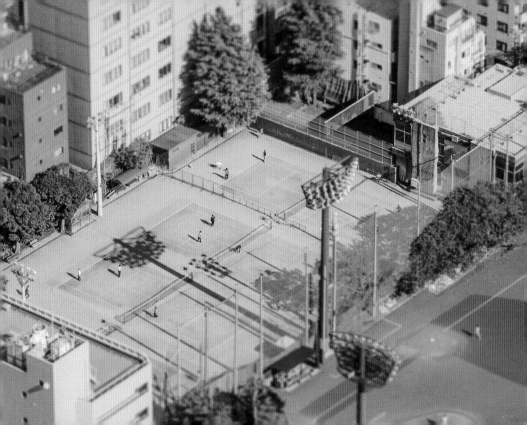

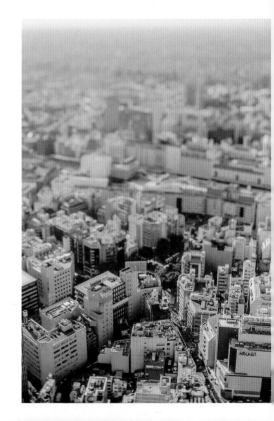

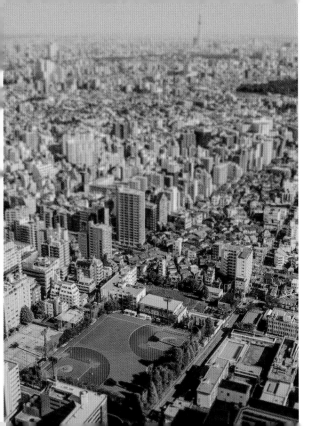

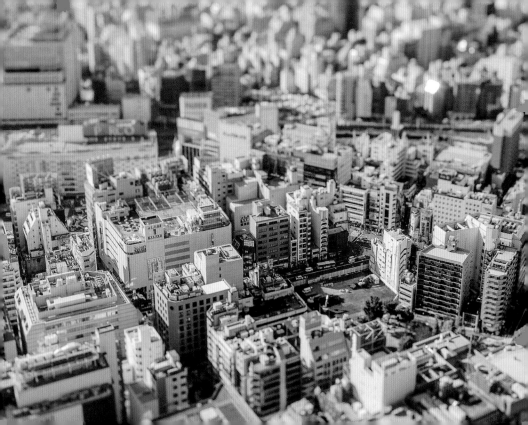

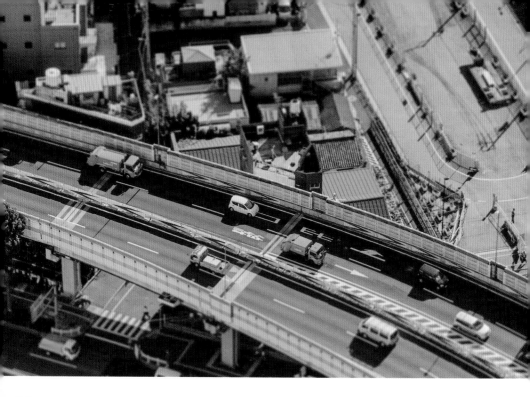

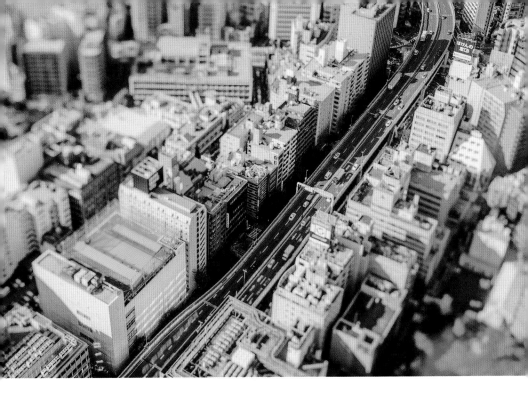

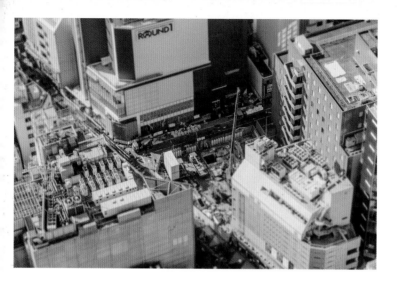

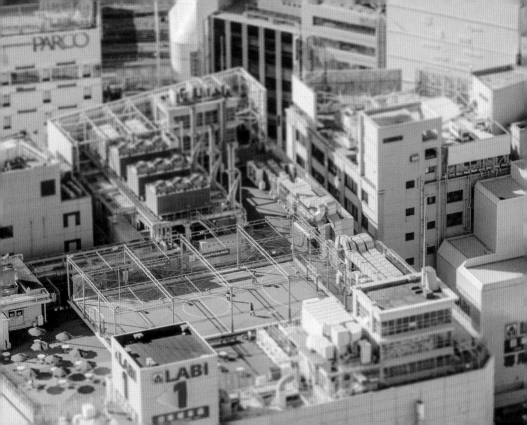

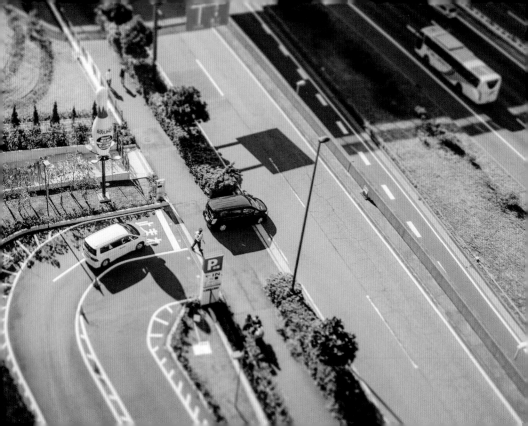

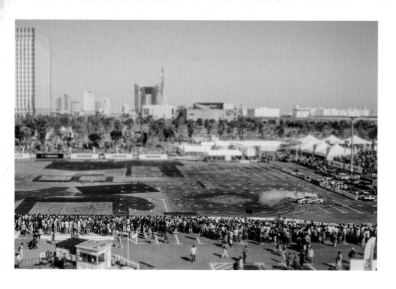

↑ ODAIBA CAR SHOW

← ODAIBA CAR SHOW DEMO

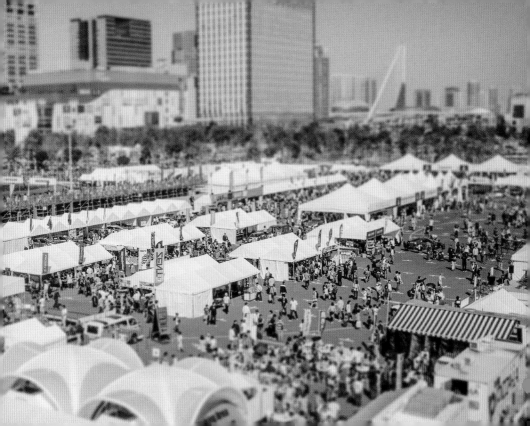

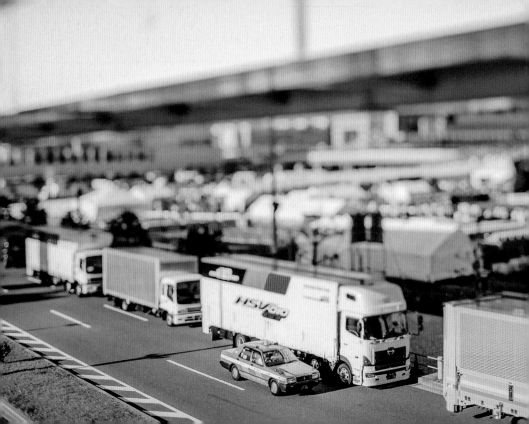

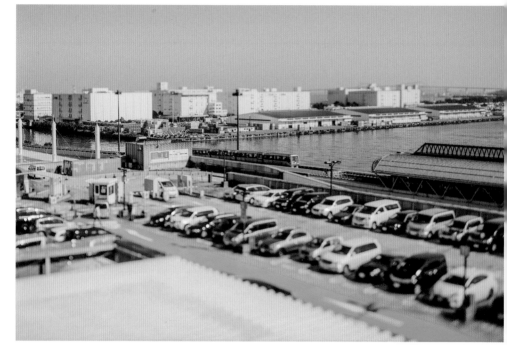

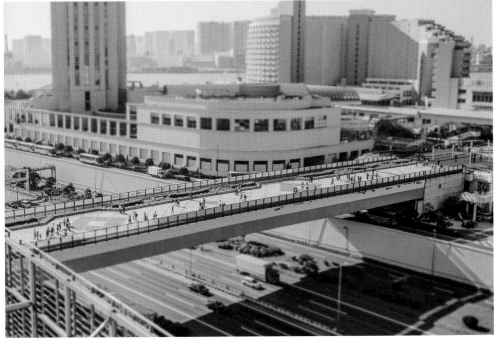

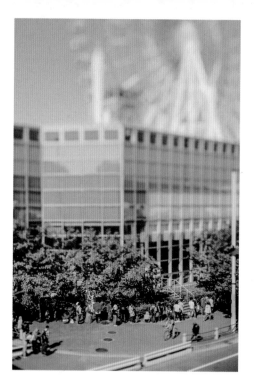

→ TOKYO TELECOM CENTER, KOTO

← CONCERT LINE, ODAIBA

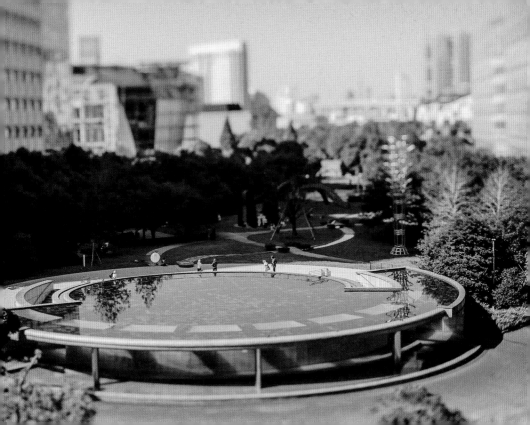

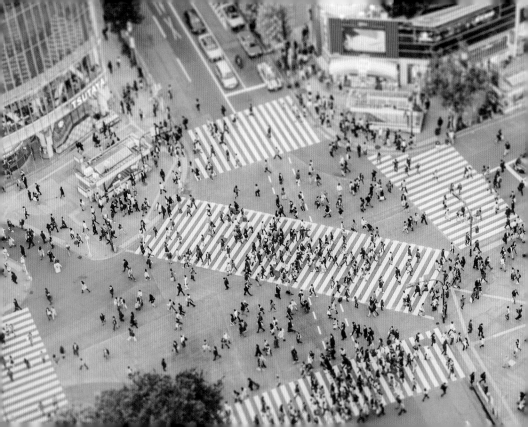

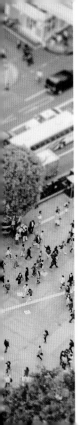

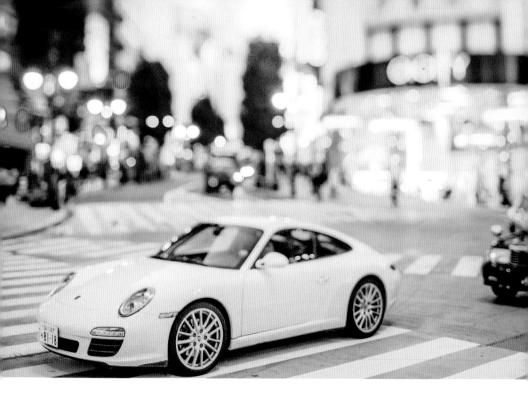

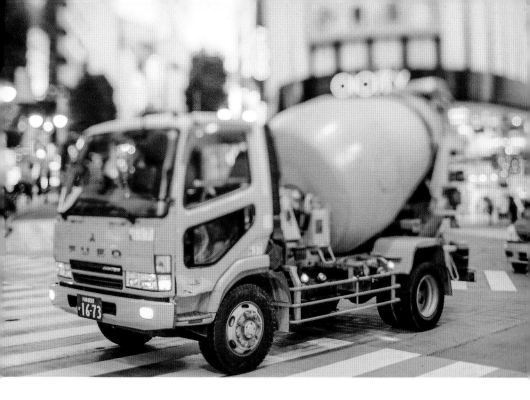

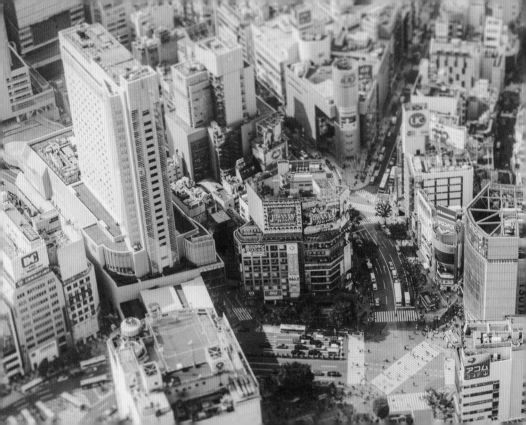

↑ → ROOFTOP SOCCER, SHIBUYA

← HEART OF SHIBUYA

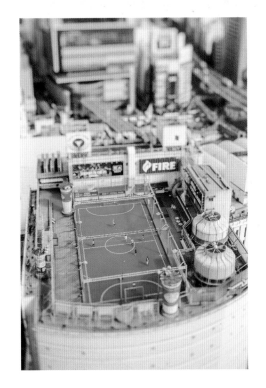

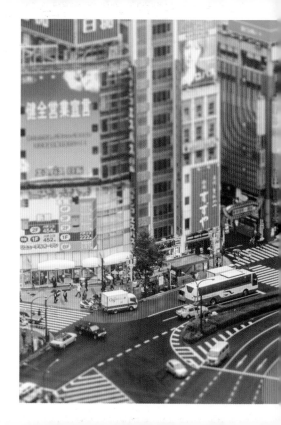

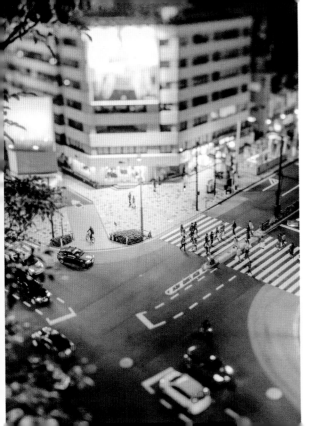

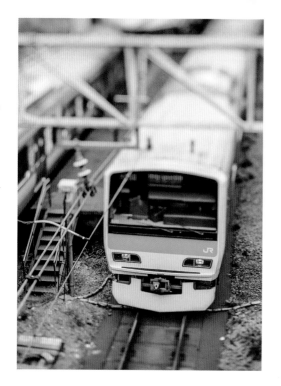

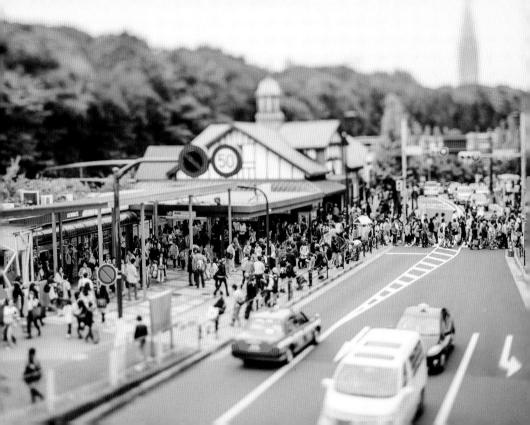

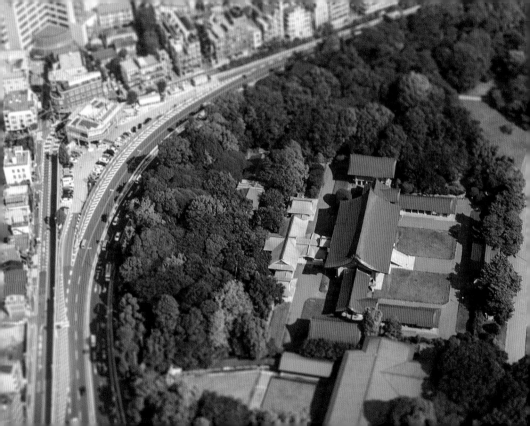

MEIJI SHRINE, TREASURE MUSEUM ANNEX, SHIBUYA

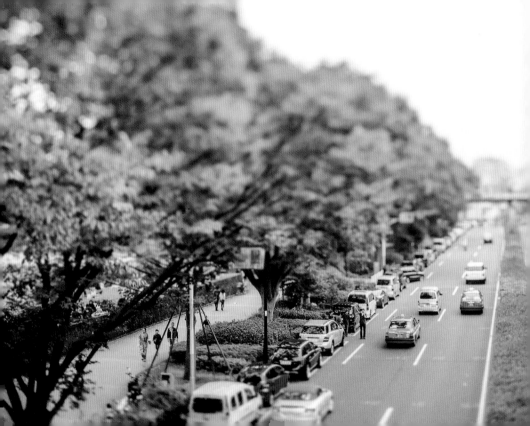

EATING LUNCH AT YOYOGI PARK, SHIBUYA

HAILING A CAB FROM YOYOGI PARK, SHIBUYA

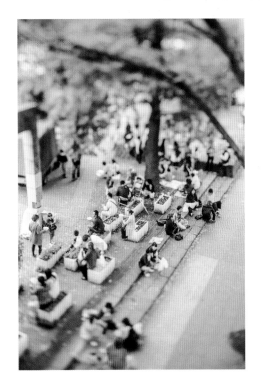

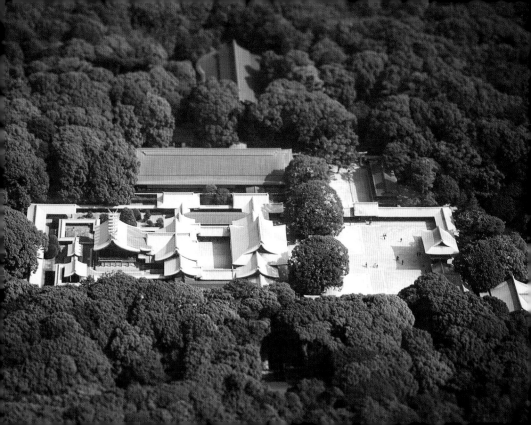

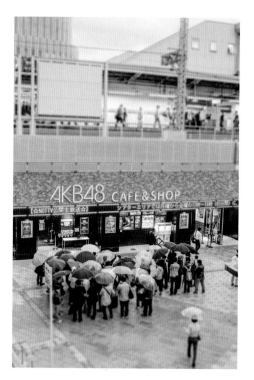

SECURITY OFFICERS, AKIHABARA

CAFE AND SHOP, AKIHABARA

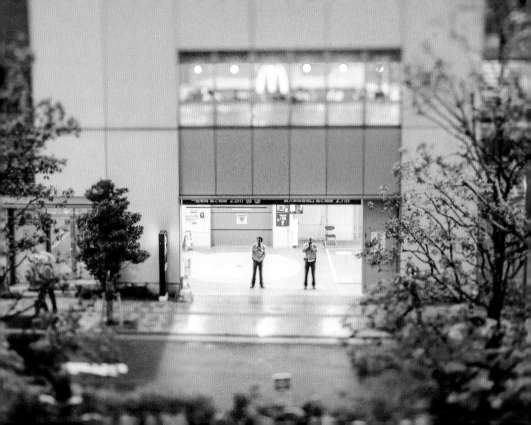

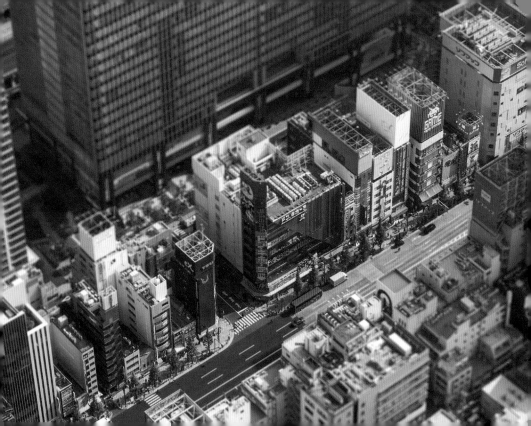

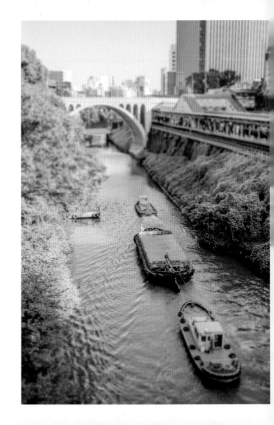

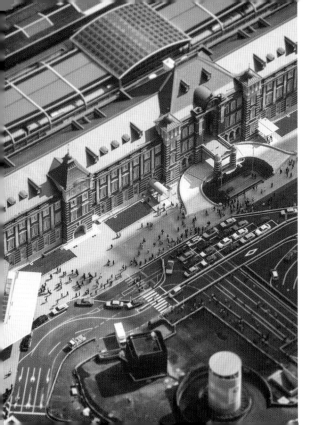

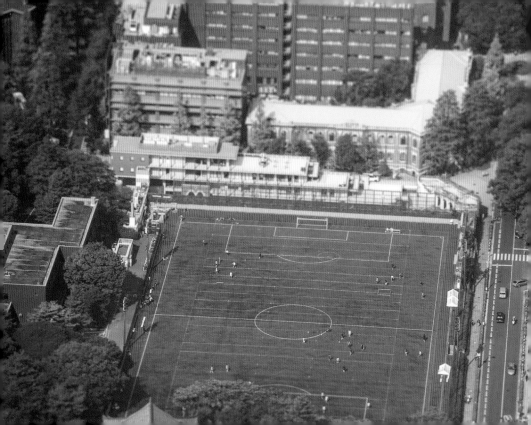

→ KOISHIKAWA KORAKUEN GARDEN, BUNKYO

→ SHINOBAZU POND, UENO

← UNIVERSITY OF TOKYO SOCCER, BUNKYO

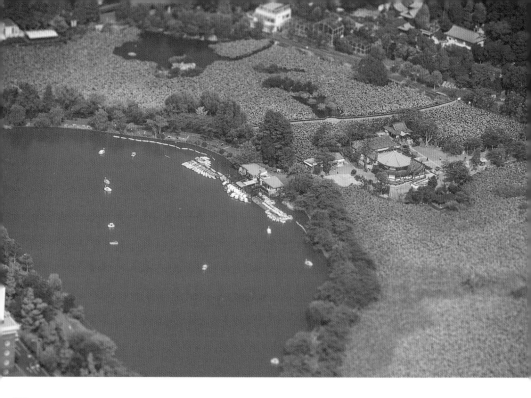

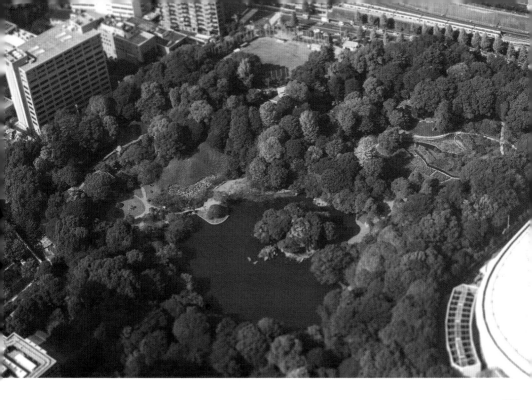

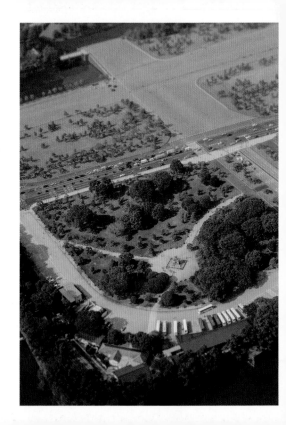

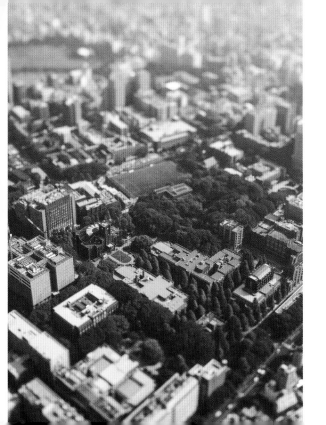

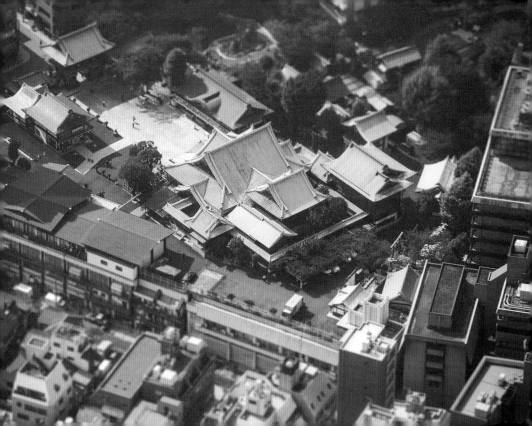

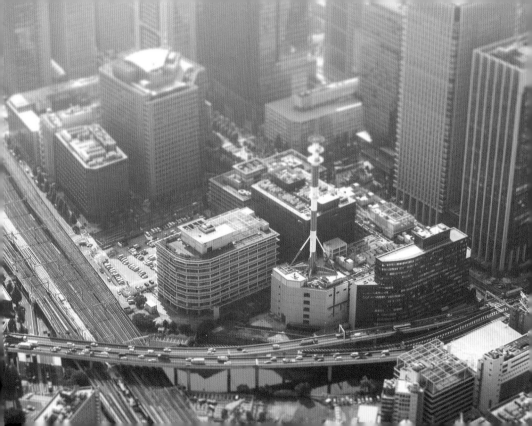

→ TOKYO TOWER, MINATO

← KANDA DISTRICT, CHIYODA

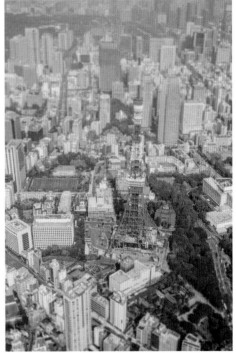

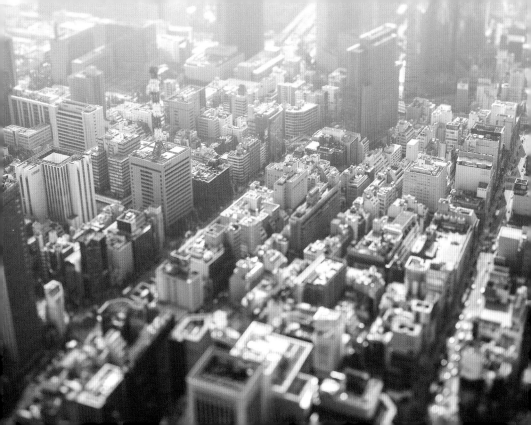

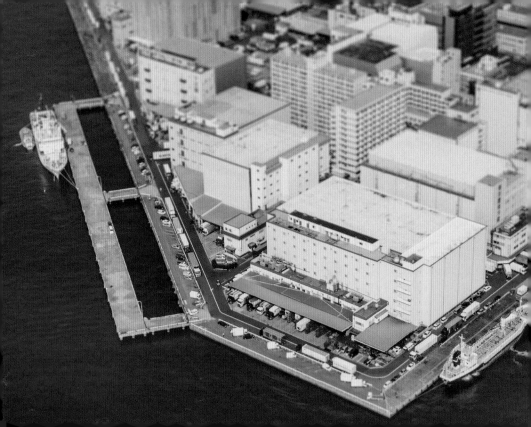

→ KAIGAN MAN-MADE ISLANDS

→ KYU SHIBA RIKYU GARDENS, MINATO

← TOYOMICHO SHIPPING, CHUO

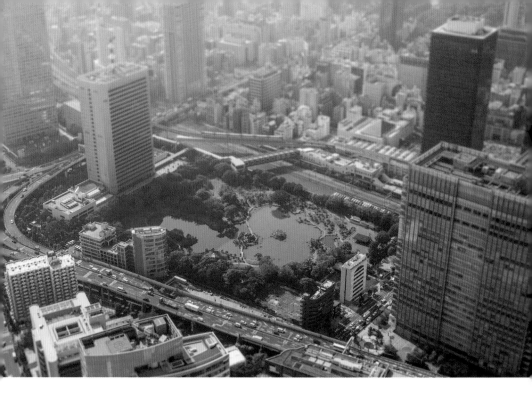

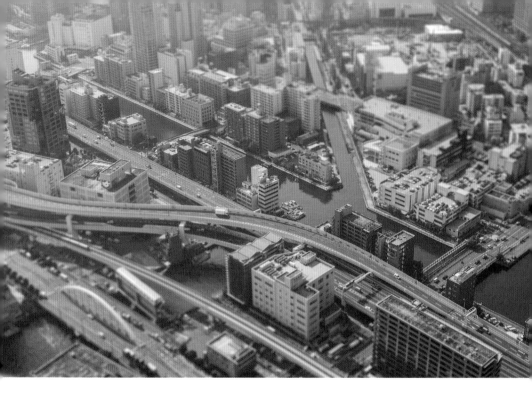

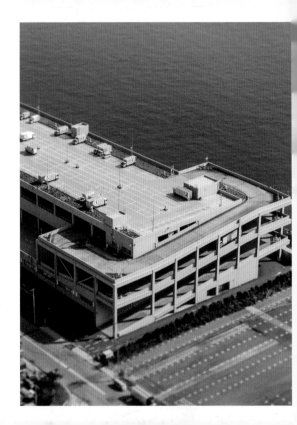

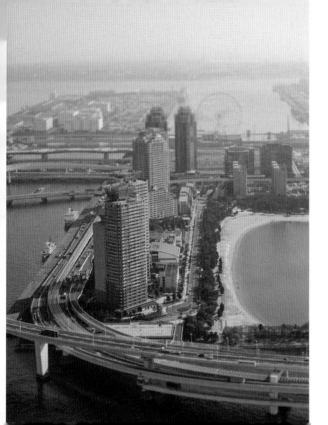

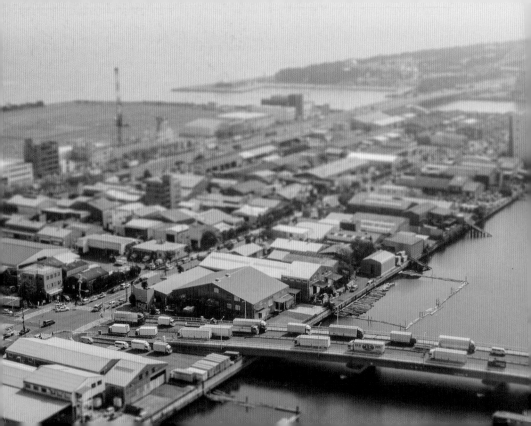

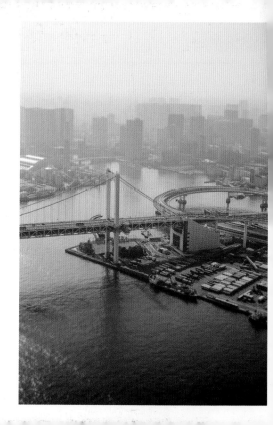

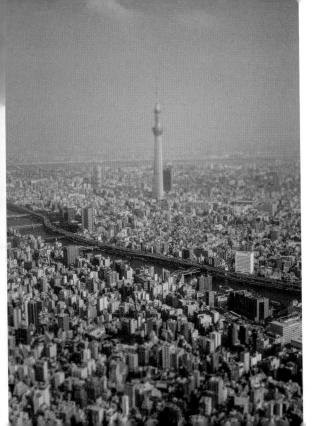

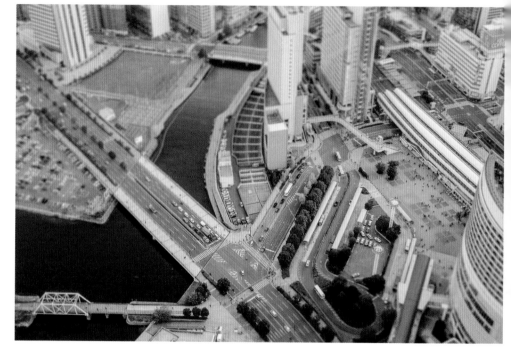

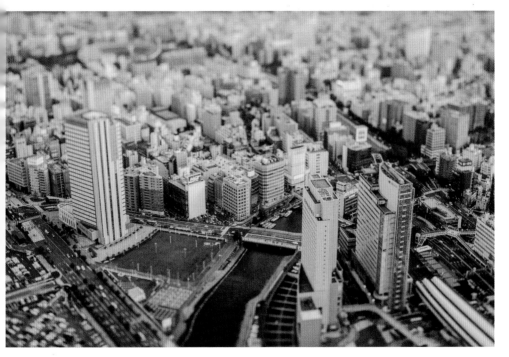

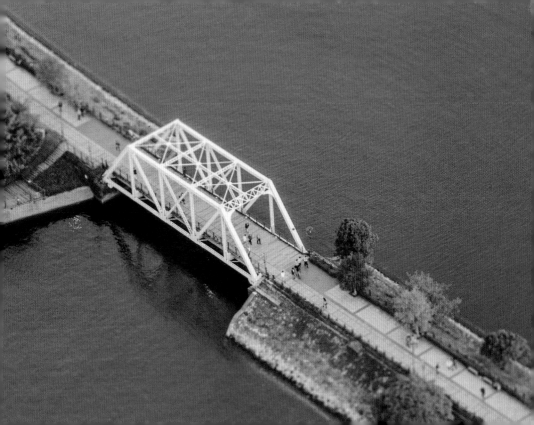

# Tokyo

0    1    2 miles

0   1   2    3 kilometers

Ikebukuro   188   191   Tos
193   192   185
186   190   182   187
181

Shuto Ex
No 5

Takadanobaba
94   95

Shinjuku
102    210
105   98   96
91   104   109
90   100
101

Shinjuku Do

108   Shinjuku Gyoen

Meiji Shrine   214
Yoyogi Park   219   212
217   213
216   107
211
207   206
208   204   88   Shibuya
209   92

Roppongi

Shuto Expwy No 4

Setagaya

Shuto Expwy No 3

No 2

67   69
68

Sangenjaya

Shuto Expwy

To Yokohama

Kanagawa

Nishi    Minatomirai    Yokohama Harbor

Sakuragicho   248   251
249

Yokohama Stadium

Minami    Naka

**Yokohama**

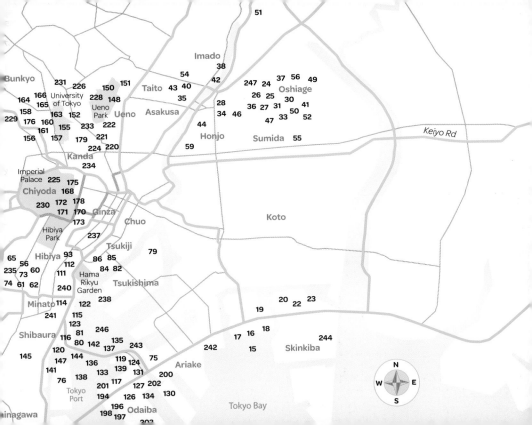

Bunkyo
231 226 150 151
164 166 University 228 148
165 of Tokyo
158 163 152 Ueno
229 176 160 155 233 222
161 179 221
156 157 224 220
234
Imperial
Palace 225 175
Chiyoda 168
230 172 178
171 170
173
Hibiya
Park 237
Tsukiji
93
65 Hibiya 86 85 79
56 112 84 82
235 73 60 111
74 61 62 Hama
240 Rikyu Tsukishima
Garden
Minato 114 238
241 122
115
123
Shibaura 116 246
81 135
145 80 142 137 243
120 144 136 119 124 75
147 141 133 139 131 200
76 138 117 127 202
201 126 134 130
194
Tokyo 196
Port 198 197 Odaiba
inagawa

51
Imado 38
54 42
Taito 43 40 247 24 37 56 49
35 26 25 Oshiage
28 36 27 31 30 41
34 46 33 50 52
47
44 Keiyo Rd
Honjo 59 Sumida 55

Koto

20 23
19 22
17 16 18 244
242 15 Skinkiba

Ariake

Tokyo Bay

N
W E
S